Inversions

Inversions

Inversions by Scott Kim

a catalog
of calligraphic
cartwheels

foreword Douglas R. Hofstadter
backward Jef Raskin

BYTE Books
A division of McGraw-Hill
70 Main Street, Peterborough, N.H. 03458

To my parents.

Copyright © 1981 by Scott Kim

All rights reserved. No part of this book may be
reproduced, recorded, copied,
or transmitted for public or private use
(except for brief excerpts used in
reviews) without permission of the author.

Sky and Water I, page 112 © BEELDRECHT, Amsterdam/VAGA, New York 1980
Collection Haags Gemeentemuseum

Metamorphose (excerpt), page 113 Image provided by Vorpal Galleries;
San Francisco, New York City, Laguna Beach, CA

Library of Congress Kim, Scott
Cataloging in Publication Data Inversions.
Bibliography: p. 119.

1. Visual perception. 2. Words in art. 3. Symmetry.
I. Title
N7430.5.K6 701'.1'5 80-24790
ISBN 0-07-034546-5

Printed in the 10 9 8 7 6 5 4 3 2 1
United States of America

Contents

7 Contents

9 Foreword

15 Introduction, Acknowledgments

Images 20 Words—Short

28 Words—Describing Symmetries

37 Words—Long

45 Variations—On *Gödel, Escher, Bach*

51 Variations—On Calligraphic Themes

59 Names—Contemporary

67 Names—Historical

74 Names—Personal

Text 81 Background—Symmetry

89 Background—Vision

93 Background—Letterforms

99 Experiences—Processes

104 Experiences—Examples

109 Associations—Music

111 Associations—Wordplay

113 Associations—Art

115 List of Images, Bibliography

121 Backword

Douglas R. Hofstadter

Foreword by Douglas Hofstadter

IT IS A PLEASURE and an honor for me to write the foreword to this, the first book by Scott Kim. Scott has been a close friend now for several years, and his friendship has been both delightful and inspiring. When we first met, there was some mutual suspicion, each of us wondering just a bit whether the other one might not be something of a crank. I had put out a flyer publicizing a course I was going to give at Stanford, and everything in my description struck such a resonant chord in Scott's mind that, to him, it sounded perhaps too good to be true. So Scott came to my office to investigate this unlikely sounding character. But when he came in, then it was my turn to wonder, "Who is this guy? Why is he so interested in my bag of tricks?"

What I remember of our first conversation is that Scott seemed to have already thought of all the things I described as my pet projects. When I said that I would love to use a computer music system to synthesize a certain Bach canon in a tricky way so as to create an aural illusion, Scott said, "Yeah, yeah! I've thought of that, too." "Well," I thought to myself, "either this guy is the most amazing character you've ever met, Hofstadter, or he's a super crackpot." At the very same time, Scott was entertaining similar thoughts about me!

Happily, we soon discovered that—at least from our own idiosyncratic points of view—we weren't crackpots. Or maybe we are both crackpots—but we haven't yet noticed it. As Scott and I got to know each other, we found remarkably many areas of overlap, but there also appeared great dissimilarities in other domains. For both of us, I think our friendship has been a lesson in how similar two people can be in certain ways while in other ways being utterly different.

Scott asked me to tell, in this Foreword, something about my own interests in letterforms, symmetry, and thought processes, since they dovetail so well with his book. I will do that shortly, but first I'd like to describe our resonance of minds—one of the most exciting things ever to happen to me.

Together, Scott and I have enjoyed music, mathematics, art, philosophy, science, computers, language, typography, and, perhaps most of all, humor. I have to say that I think that the mixing of humor with all of our serious interests is one of the most characteristic things that Scott and I have in common. It seems that the joy of making crazy, wild speculations is closely related to the joy of making crazy, humorous observations about nearly everything serious. It reminds me of the descriptions of some of the mathematicians in Stanislaw Ulam's exciting autobiographical book *Adventures of a Mathematician*—people whose intellectual joy spills over into their lives in a complex and lovely way. Discussions at the Scottish Café in Lwów in the 1920s may have been a little like some of the discussions Scott and I have had, in their joy of exploring ideas and of bouncing from one topic to another in a spontaneous and totally chaotic way, led more by jokes than anything else. And yet, these discussions always come back to certain central themes that fascinate Scott and me. They are never so random that we get lost. Instead, it seems that we are always meandering in a dense, coherent web of ideas and occasionally veering off toward the edge, finding ways to extend it and refine it.

In these discussions, we seem always to come back to the question of how people perceive, think, and create. And since we are both ardent believers in the power of analogies and examples, we do not stop at the purely logical. We find it more stimulating to jump into dangerous territory: We are fascinated by leaps of intuition, unlikely connections and mappings of ideas onto each other, strange associations, and so on. I think that it is this overarching interest in perception and artistic creation, together with a passion for the formalisms of mathematics, computer science, and science in general, that best characterizes the style of our interaction.

Perception and creation—two things that powerfully motivate Scott. Ah, but I have left out one more essential ingredient: the love of the absurd, the impossible, the

paradoxical. Or perhaps that ingredient is implicit in creation. Perhaps the joy of creation is the joy of doing the impossible. I'm not sure. In any case, what is absurd one day certainly becomes mundane the next. Art is a continual push toward the absurd, engulfing the absurd and then redefining the term so that it means something that formerly was inconceivable. In this sense, forward motion in art is deeply related to paradox and absurdity. I want to illustrate this fascination with the absurd in a concrete way, so I will tell a little tale.

I first heard about the wonderful puzzle called the Magic Cube or Rubik's Cube sometime in the spring of 1979 when I was at home in Indiana. It was from Scott, who had called me up from Stanford to communicate his usual bag of recent magical discoveries. I'm used to that. Somehow Scott establishes connections to the most unusual people and through them always seems to come across things that have an air of paradoxicality or impossibility about them, which he shares enthusiastically with everyone who will listen.

Well, this time, he began by telling me that a mathematician who was passing through Stanford had brought along a strange 3x3x3 cube made out of plastic. It came from Hungary, Scott said, and had everyone mystified. "Par for the course," I thought. Scott is always telling me about things that mystify people. As he was talking, I was envisioning something like the Soma Cube puzzle—seven pieces that you can put together in many different ways to make a 3x3x3 cube. *"This* cube stays in one piece," said Scott. "Each face starts out a uniform color," he went on, "and you can"—but before he had finished, I started to groan. "Oh, no!" I said, anticipating the worst sort of impossibility I could envision (of course, "worst" means "best" here). "You mean every single face can *turn?* That's ridiculous!" "Yup," said Scott, "it certainly is ridiculous. But it's real." And then, while protesting the total absurdity and self-evident impossibility of this obviously fictional object, I chuckled with glee and tried to imagine how in the world it could hold together. Thinking about how to *solve* the puzzle itself was not my concern yet, although it would in time become an obsession.

After the fact, it struck me that with no one but Scott could this conversation have happened. With most people, you just don't anticipate that what they are going to tell you

about is the maximally inconceivable thing, but with Scott it's just the reverse—and that's part of the joy of knowing Scott. One time, in describing Scott to a friend, I came out with the phrase "double-jointedness of the mind", which I think says it perfectly.

One of the first things I found I shared with Scott was a fascination with the mysterious fluidity of letterforms and the way they form words on paper. The mystery of wholes versus parts is always awakened when one ponders the relationship between words and letters. I have always been astounded by the fact that when people read, they gulp up words as wholes, somehow almost bypassing the letter level—almost as if they could read words without needing to have the letters there at all! The letters in a word form such a tight community that one grows used to the community independent of the individuals that compose it.

But the same happens at the letter level. One perceives letters almost independently of their strokes. With the teeniest wavering in a line, you can convey an entirely different letter from what it would have been without that wavering. You can omit strokes, insert extra strokes, combine strokes, break strokes into pieces, hint at them, in fact, play endless perceptual games with the strokes that form a letter. What it is about the letter that remains invariant is one of the hardest things under the sun to characterize. It is like asking what is the same about all the different shapes that my body can form when I stretch and bend and squat and jump. Yet any friend of mine could, in an instant, recognize me in any of those positions.

I have a favorite saying about the discipline of artificial intelligence—my research area—which goes this way: "The central problem of AI is: 'What is the letter "a" ?' " A friend added, "And what is the letter 'i'?" What I mean by my little slogan is that if we had programs that were as fluid as we are in seeing words and letters where there are mere strokes, we would have created genuine machine perception, and therefore, in my opinion, genuine machine cognition. Scott's inversions should convince anyone who hasn't recognized it before that human written language is one of the most bafflingly slippery things imaginable. The mere idea that we can consciously recognize wholes without consciously recognizing their parts is, to me, a far greater mystery than the secret by which the Magic Cube holds together.

I have always felt a sense of wonder and awe when I look at a sheet full of symbols in an exotic writing system—say, that of Tamil (a language of southern India). That those particular geometric combinations of strokes somehow represent certain human thoughts is quite astonishing. There is a kind of harmony to the dense interplay of curves and lines, sometimes crisscrossing each other, sometimes curving around and gracefully near-missing each other, sometimes abruptly stopping and changing directions. For years, I found it fascinating to think about a set of rules that would distinguish a page of meaningful Tamil text from a page of Tamil letters thrown together by a random-number generator. To most people, the two pages would appear indistinguishable. Yet if you had enough Tamil text in your library, you could compare the two sample pages to it and you would find telltale cues—purely visual ones, mind you—that revealed the impostor. This implies that, in some sense, a page encoding meaningful thoughts is *geometrically* a different kind of entity from one without any sense behind it. Its meaning and its shape are just two sides of the same coin. The more I thought about this idea that one can flip back and forth between shape and meaning, the more I became convinced that the deepest of content is but form manifesting itself in an intricate way. Or, if you prefer, meaning is just fancy shape. Content is just fancy form. And I can think of no person who better exemplifies this notion than Scott, whose fanciful forms are certainly as full of content as anything I can imagine.

As much as I am fascinated by the question "What is the letter 'a'?", which I call "the vertical question", I am currently even more fascinated by another related question about alphabets, which I call "the horizontal question". The vertical-horizontal distinction is illustrated by the matrix to the right.

The idea is simple. The alphabet is written in various typefaces. If you scan vertically, your eye runs down a column of "a"s in different typefaces and the appropriate question is, "What do all these things have in common?" For some reason, we are tempted to answer, "The same shape"—knowing full well that if that were the answer, they would all look identical, which of course they don't. Still, it lingers in our mind that *some* sort of abstract, platonic "a"-shape lurks behind each of the "a"s. But now we carry the question one step further. If you scan horizontally, your eye runs across a row of different letters in one typeface and again the appropriate question is, "What do all these things have in common?" Clearly they have *something* that binds them together, as much as do two pieces by one composer. Each piece by Chopin carries the unmistakable Chopin signature in its fiber, no matter how much it may differ in other respects from other Chopin pieces. A waltz, a scherzo, a mazurka, a polonaise, an étude, an impromptu—even a tarantella or a barcarolle—they all bear the same stamp. And the same goes for letters belonging to a single typeface. They all have been cut from the same stylistic cloth—but how to characterize what that cloth is? How to get at it in exact, computational terms? This is a near-paradox—to encapsulize in a fixed set of rules the essence of creativity that allowed that designer to come up with all those ingenious curves, twists, hooks, angles, cusps, and so on, that imbue the typeface with its elusive yet undeniable artistic unity.

Letterforms conceal arbitrarily deep mysteries. We are only now coming to see this with clarity, as we attempt to mechanize the many ways we deal with letters. It seems

an infinite challenge to impart to a computer the fluid understanding of letters that we all intuitively have. To see just how fluid our conceptions of letters are, we have to see how far we can stretch letters and still have them retain their identities. We have to explore the "typographical niche" occupied by each letter and see where it begins to overlap with other letters' typographical niches. There is no better way to carry out such explorations than through humorous distortions of letters or through games based on letters and their shapes.

For example, one day, long after I knew Scott and his love of letterforms, I was talking to him about my idea of making a computer program that could infer an entire style from a few sample letters. To make the task concrete I took what I considered to be one of the gutsiest letters I had ever come across, and proposed that we both generate an entire alphabet based on the ideas that it suggested to us. Here is the letter, a lowercase "a":

I called the alphabets that Scott and I created "Boxy SEK" and "Boxy DRH". Can you carry out the challenge? See what you learn about letters by trying to create your own typeface. Beware: Sometimes a casual interest in typefaces can become so obsessive that it carries beyond letterforms and you find yourself imagining solid objects such as coffee cups and table legs in a particular typeface. At about that point, you know you've got the typeface bug.

In my college days, I played another letter-based game involving the strange idea of creating symmetries in words that had none. My friend Peter Jones first suggested this, and he and I made many silly distortions of letters in order to make our own names, or those of friends, be readable both forward and in a mirror. We were not very good at it, for we never came across the key insight that Scott has learned to exploit, namely, that letter *parts* can be regrouped so that what is one letter going one way may be two letters or half a letter when read the other way. In any case, we enjoyed ourselves, and I still am pleased

every time I open my copy of Howard Bergerson's book on palindromes and anagrams and see my very own forward-backward signature of ownership:

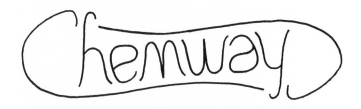

Actually, I dislike the mixing of an uppercase "r" with lowercase letters, but it was the best I could do.

Among my earliest efforts was the company name "Chemway", which I chanced across in a newspaper. Somehow, it flashed into my mind that here was a word that lent itself beautifully to upside-down play, as follows:

One evening soon after I'd met Scott, we were sitting in the Stanford Coffeehouse and he was showing a couple of us some of his letterplay. He pulled out a sheet of words that worked in two ways. I was flabbergasted. Someone else had done this? A kindred spirit! So I grabbed a napkin and reconstructed my "Chemway" and a couple of others I remembered doing. But soon I saw that Scott had carried this art far beyond what Peter and I had envisioned back in college. I am reminded of the development of the musical form of fugue. The Italians had invented the form and written some nice fugues—then along came Old Bach and showed everyone what a fugue really could be. Similarly, Scott had turned what had been to us a silly diversion into a genuine artistic form, a domain in which problems of many sorts could be posed and solved with stunning ingenuity and grace.

"Grace" is certainly one of the key words in describing Scott's work—in fact, in describing Scott's general style in life. Any reader of this book will soon discover that its prose breathes a special kind of life into it. Scott's prose is, to my mind, just as graceful and fluid as are his letterforms.

It is playful and elegant, full of surprises and nonobvious puns, and has a completely idiosyncratic structural beauty. I see Scott's sentences as a rapid series of lightning flashes brilliantly illuminating one landscape after another. Instead of focusing a bright light on any one topic for so long that the reader's mind gets overexposed, Scott's *Blitzprosa* sparks for an instant, leaving hints scattered all over the back of the reader's mind, then quickly flits off to spark somewhere else. The reader is left with all sorts of potential connections to explore and savor at some later time. Far from being shallow, the style is poetic.

I think it is about time to stop. I know that this foreword is unusually personal in flavor, but truly I would not have felt comfortable trying to introduce Scott without bringing in my feelings of friendship, warmth, and admiration. I am privileged to know Scott personally. Many readers will now become privileged to know Scott through his lovely and inspiring artistic creations.

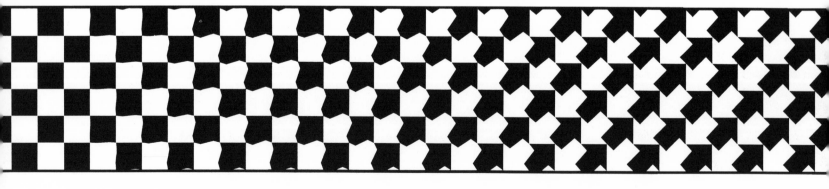

Introduction

Why, it's a Looking-glass book, of course!
And, if I hold it up to a glass,
the words will all go the right way again.
—Alice, from *Through the Looking-Glass*

LIKE MOST BOOKS, this book is made of words. The words in this book, however, are meant to be seen and not read. Each word has a special visual trick, something to fool your eye. Some of the words read the same upside down, some read the same in a mirror, some repeat off to infinity. Sometimes one word will be hidden inside another (you may have to look twice). Always I have tried to make the style of the lettering reflect the meaning of the word. Thus the form echoes the content. In turn, I have chosen words that reflect the idea of playing with symmetry, both in art and in science.

i am often asked what this brand of wordplay is called. As far as I know, there is no standard name currently, even though the idea is quite old. Scot Morris of *Omni* magazine proposed the term *designatures*, which suggests, through its ambiguous pronunciation, the two-headed nature of the activity. One is also reminded of palindromes and other forms of wordplay, as well as the perplexing interlocking shapes of the artist M. C. Escher.

For the purposes of this book, I will use the word *inversions* to refer to all varieties of symmetric lettering. The word has many connotations: turning upside down, reflecting in a mirror, pivoting around a point, subverting expectations, and exchanging roles. The word also occurs in geometry (inversive geometry) and in music (invertible counterpoint).

Personally, I connect designing inversions most closely with writing musical canons—the mental juggling feels quite similar. The essential theme of *Inversions* is that we can see the nature of a subject more clearly when we turn it upside down.

How can a word possibly read the same upside down as right side up? Normally, when you turn a book upside down, it becomes illegible. Only a few letters, like "o", remain the same. In order to make a whole word read the same both ways it is necessary to stretch the shapes of the letters. Fortunately, our alphabet is very pliable. The great variety of type styles we see in print has trained us to recognize many different shapes as a single letter. If it were not for this flexibility, inversions would be impossible.

My first inversion was in fact one of the most unusual. I was quite lucky to have started with such a challenging theme. In 1975 I attended a class in graphic design. One of the assignments was the following:

> Produce a flat design in two or more colors that has no background: that is, one in which the spaces between forms are as positive as the forms themselves (as in a checkerboard). The objective is to make all of the parts of your composition interrelate—use all of the space and make it all work.

Foreground and *background* are also known as *figure* and *ground*, respectively. One way (but by no means the only way) to interrelate figure and ground is to make them exactly the same shape. In the figure on the left, for instance, the spaces between the black arrows form white arrows. If we repeat this pattern, we can cover the whole plane with alternating black and white arrows.

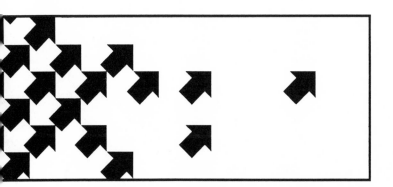

Of course, there are many other shapes besides arrows that will fit together to cover the plane. The artist M. C. Escher devised many ingenious human and animal forms that interlock with copies of themselves to fill space. Discovering such a shape is a fascinating and often frustrating experience, a real exercise in give and take. On the one hand, the outline must make a recognizable shape; on the other hand, it must fit snugly with copies of itself—for every "in" there must be an "out".

Most of the students in my design class chose to work with animal or other pictorial shapes. As the teacher had encouraged adventurous solutions, and as letterforms had always attracted me, I decided to work with the words *figure* and *ground*.

The first possibility that suggested itself was for the spaces within the **FIGURE** to form the **GROUND**—a nice visual pun. After repeated failures at this combination, I arrived at the intermeshing of **FIGURE** with itself shown above. If you turn this design over, you will see that the spaces between the letters in the white **FIGURE** make an upside-down black **FIGURE**. (It may take a few moments for your eye to "lock" on the word.) Notice how **F** fits with **E**, **I** with **R**, and **G** with **U**. Notice also how some of the letters have been run together. **R** has been almost lost. The **F/E** combination works particularly well; a similar technique would work for **F/F** or **E/E**.

Forcing a word to mesh with itself can cause strange things to happen to the letters. In a figure/ground inversion, every line must serve as the boundary of two different letters. Occasionally the two letters fit into each other perfectly, but more often than not they tend to push the boundary in two different directions. Most of the time I spent developing **FIGURE** went into finding compromises that would still yield legible letterforms.

The letter that suffered the most was the **I**. Unfortunately, straightening out the unwanted bump would destroy the recognizability of the **R**. "Wouldn't it be nice," I wished, "if the **I** and **R** were both right side up, so that the bowl of the **R** would contain the dot of the **I**?"

(Doesn't it seem strange, dear reader, that I should talk about the dot on the "**I**", when in fact the "**I**" itself is not an uppercase "I" but a lowercase "i"? Furthermore, isn't it strange that in the previous sentence the intention of the quotation marks is not to refer just to some letter of the alphabet, but to the fact that it is bold, the fact that it is capitalized, and perhaps even what typeface it is in? After all, "**I**" is not the same as "I", "i", or "I". (I don't want this nesting of parenthetical and self-referential comments within parenthetical and self-referential comments to get too baroque (or maybe (dear reader) I do) but I do want to call attention to the manifold difficulties in referring to letterforms.) The convention I will use throughout this book is that references to letters that appear as parts of inversions will be printed in **bold** UPPERCASE letters, even when the letter being referred to is in lower case.)

I decided to follow this possibility further. If **I** were to fit with **R**, with both letters upright, then working backward, **F** would have to fit with **U**, and working forward, **G** with **E**. This eventually gave rise to the repeating pattern shown above. The letters jostle around quite a bit but maintain their legibility surprisingly well.

As you look at this inversion, your mind will oscillate between two different interpretations: black letters on white background, and white letters on black background. Which do you see first? If you practice, you will find that you can "flip" your interpretation at will—a good demonstration that the meaning of a picture is in the mind of the beholder. It is nearly impossible, however, to balance your perception on the edge of ambiguity, so that both words appear equally dominant.

The evolution of an inversion contains another sort of oscillation: As you develop an inversion, you must constantly switch attention between the demands of legibility and the demands of symmetry. Putting legibility in the foreground tends to make the letter shapes grow more distinct. For instance, I tried to put the correct serifs on the letters in **FIGURE** whenever possible. Letting symmetry dominate your perception tends to make the letter shapes grow more similar. For instance, the outside of the **E** was rounded to match the inside of the **G**. Out of this process of give and take often emerges a visual style that is as much a surprise to the inventor as it is to the viewer.

For the presentation in class, I cut out two copies of **FIGURE**, one in white cardboard and one in black. Before class, I placed the two words on a table at the front of the room, spelling out the word *figure* twice, once in white and once in black, without any of the letters interlocking. When it came time to present my project, I pointed to the two words. I said nothing, but soon the implicit challenge was understood.

First my classmates noticed repeated curves. Perhaps the letters were meant to fit together. Different theories were batted around as the shapes were assembled. Eventually the black word and the white word were assembled into separate solid masses. But what did this have to do with an assignment on figure/ground relationships? Someone recognized that black and white were to alternate, and finally the desired pattern was revealed.

I never did solve **FIGURE/GROUND**. But in retrospect, the **FIGURE/FIGURE** combination seems more fitting after all—a picture that is all **FIGURE** and no **GROUND**. The solution was fine; all that needed adjustment was my statement of the problem. This unexpected twist of expectations was a lovely lesson and has remained with me in my explorations. I hope that you, too, will discover new inversions as you explore your own worlds within the magic universe of letterforms.

A Note on the Text

The text portion of this book is written for people who are curious how and why inversions work. It also invites interested readers to explore fields that I have found closely related. The text is in three parts: background (symmetry, vision, letterforms), experiences (processes, examples), and associations (music, wordplay, art).

Background. In order to talk about inversions, I first need some vocabulary. In this section I introduce some of the basic concepts of symmetry, visual perception, and lettering. If these concepts are new to you, you may want to pursue them further—my own interest in typography started when I began playing with letters.

Experiences. The best way to understand inversions is to try inventing them yourself. In this section, I outline the steps in my own creative process, using actual examples to illustrate how specific ideas were developed and how choices were made.

Associations. The theme of *inversion* can appear in many disguises. In this section, I illustrate how the same upside-down spirit has been captured in the areas of music, wordplay, and art.

Finally, a comment on the writing style. The organization of this book is itself filled with many levels of symmetry. Often a series of words, sentences, or images will reappear later in a different context. When this happens, I am drawing a parallel between two different strands of thought and not merely repeating myself. Often the message will be contained in the comparison between the two strands, and not in either strand individually. This mirroring is in keeping with the general theme of symmetry. Thus the form echoes the content.

Acknowledgments

Many people contributed their special talents to help make this book happen. I want to thank all for making the journey a most enjoyable one.

The seed of inversions was planted in a design class taught by Matt Kahn at Stanford University. His creative enthusiasm dared all of us to venture into many outrageous areas of play.

Chris Morgan, Ed Kelly and Ellen Klempner have shown me how personal a publisher/author relationship can be. It was they who approached me originally, and it was their wonderfully open and encouraging attitude that nurtured this book into existence.

Throughout, my parents have been an unending source of support. I want to thank them for their encouragement, patience, and understanding.

Dick Kharibian deserves special thanks for his role in design and production. While maintaining a watchful eye for consistency, he allowed me the unusual freedom to develop my own designs. His day and night efforts are responsible for getting this project finished. I feel fortunate to have worked with him.

With the aid of Donald Knuth's typesetting language TEX and the programming efforts of David Fuchs I had the good fortune to be able to typeset my own text. I hope that more authors will be able to have this experience in the future, for it is enriching to participate in more than one aspect of book production.

After Jef Raskin saw a sketch of the cover of this book, he suggested that if a book like this had a foreword, it should certainly have a backword too . . . and volunteered to write one. I am glad that his playful sense could be included in this book.

Dianne Kanerva, I am pleased, was able to participate as copy editor. Having an editor so attentive and thorough let me breathe more easily.

Which brings me to Doug Hofstadter. Doug helped shape the manuscript with as much care as if it were his own (if not more). But more importantly, as a friend and colleague, he has insisted on a purity of vision that acknowledges both form and content. If any person's influence underlies this book, it is Doug's.

One of the most pleasant surprises in working on this book was meeting John Warnock. John has a fine perceptive sense of what matters most in computers and graphics, and his computer graphics language JaM reflects this craftsmanlike concern. Sometimes he understood my images better than I did! When I asked John if he could change the number of repetitions of the word *infinity* from 3 to 4 in the circular **INFINITY** design, he pointed out that only with an odd number of repetitions would the word come out right side up at both the top and the bottom of the circle. About a third of the images in this book were produced by using JaM to describe what I wanted to a computer.

Ginny Mickelson and Joan Carol contributed their graphic skills to a rickety but effective inversion assembly line. Ginny redrew many of the pictures in both the image and text sections.

Suzanne West was responsible for sharpening the title design into a cover. It was fascinating to see someone else spinning variations on an inverted theme. Other people who have contributed in different ways include Randy Adden, Peg Clement, Jack and Diane Gilderoy, Ellen Korn, Fanya Montalvo, and Robin Samelson.

Special thanks to Stanford University's Computer Science Department for use of their text-editing and typesetting facilities, and to Xerox Corporation for use of their computer graphics and image production facilities.

Images

(Descriptions on page 115.)

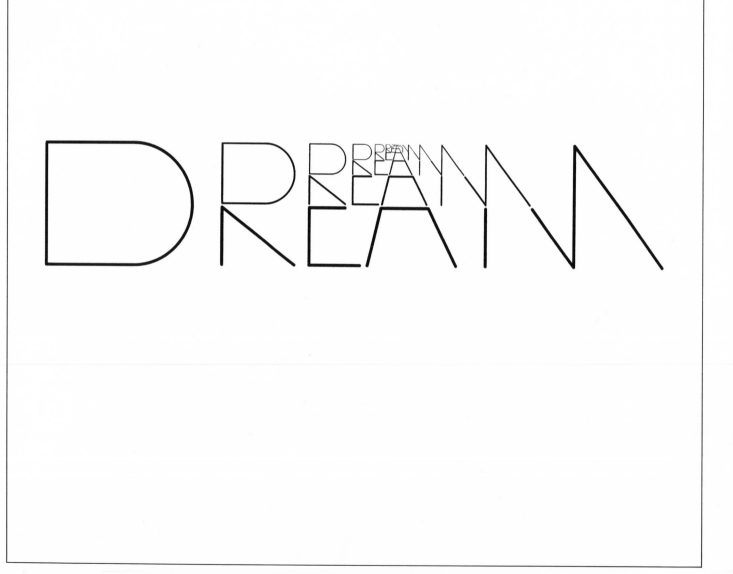

FALSE

true

MAN
WOMAN

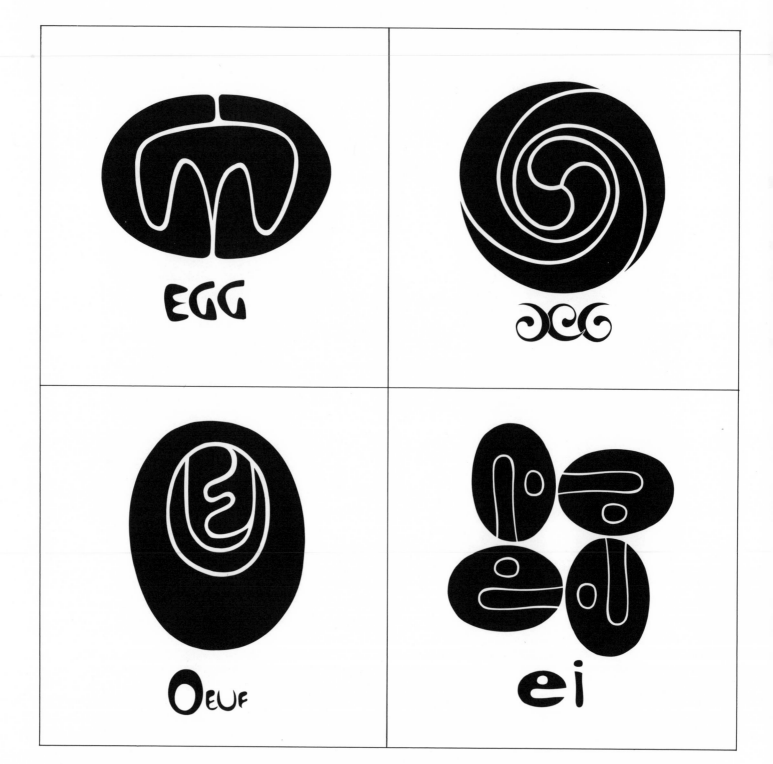

EGG

OEUF

ei

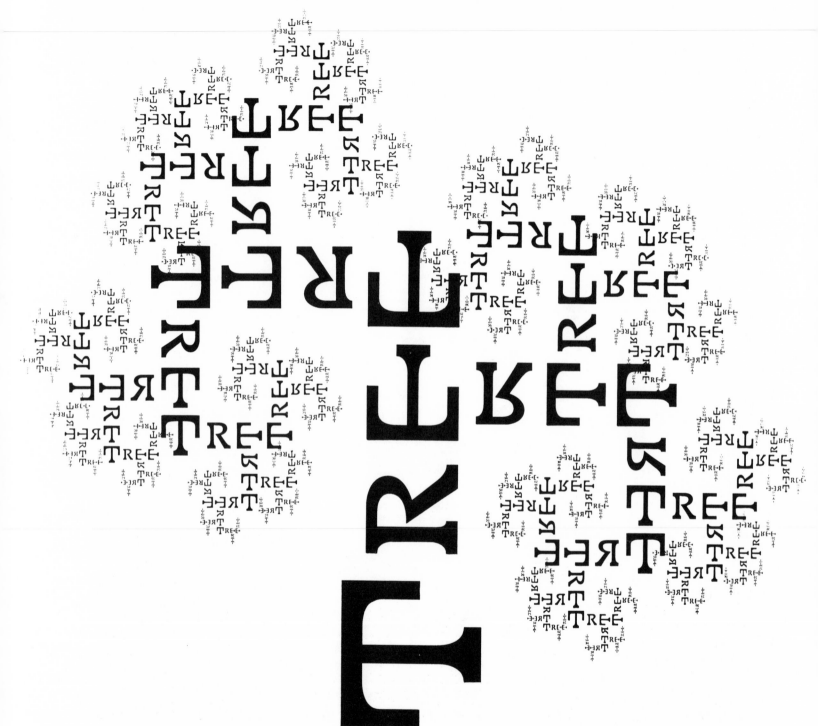

Symmetry

Asymmetry

UPSIDE
DOWN

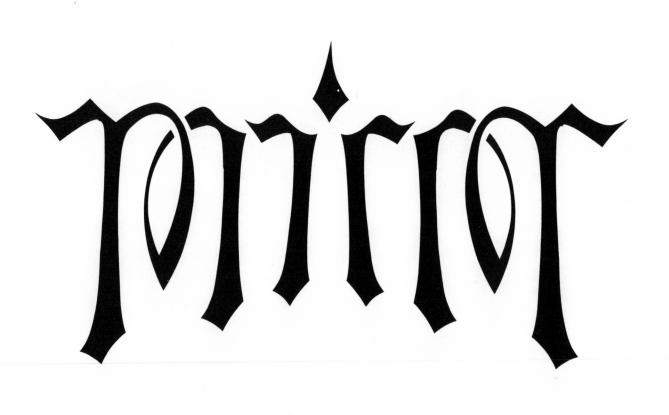

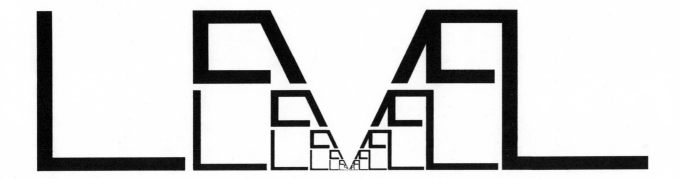

infinity infinity infinity infinity

infinity infinity infinity infinity infinity

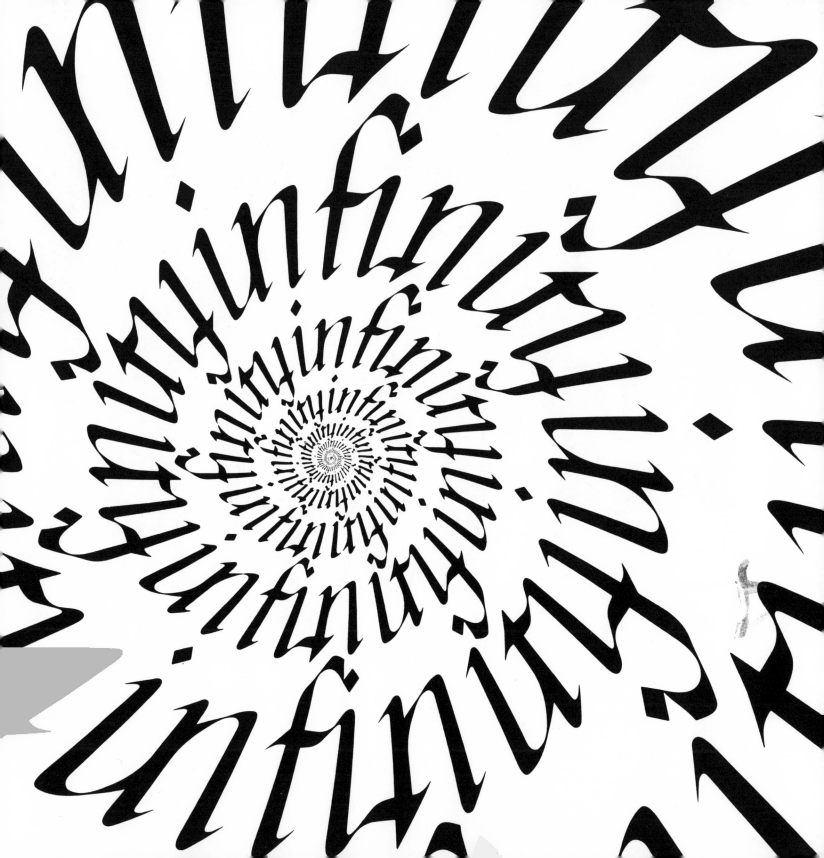

SOLUTION
PROBLEM

PROBLEM
SOLUTION

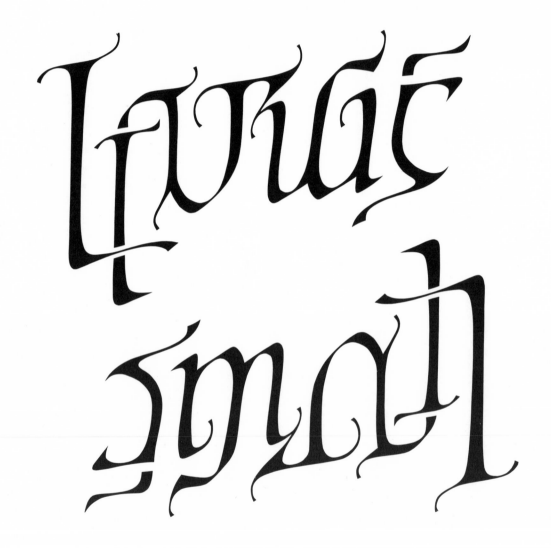

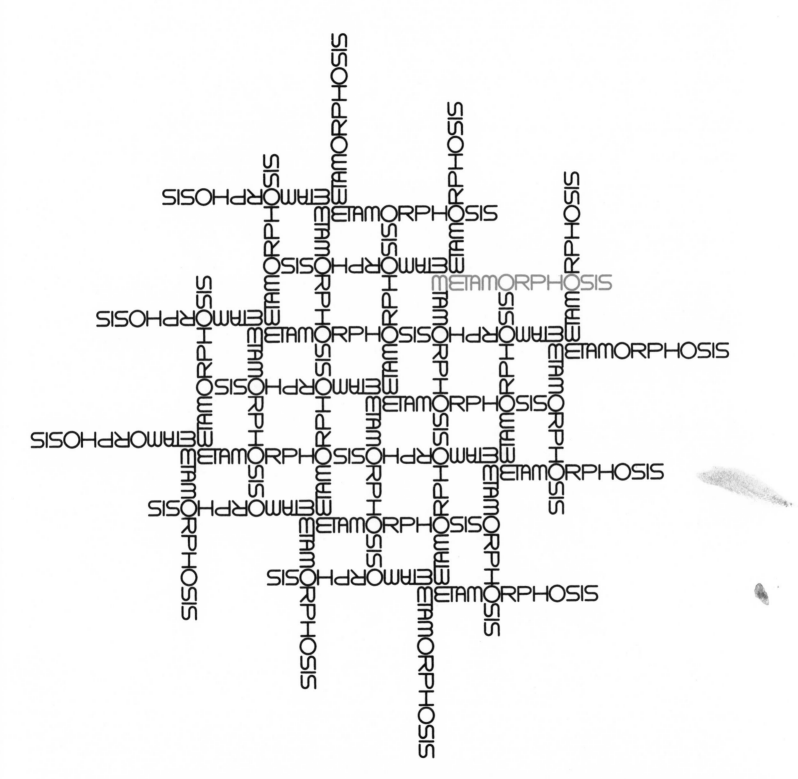

commu-
~nication

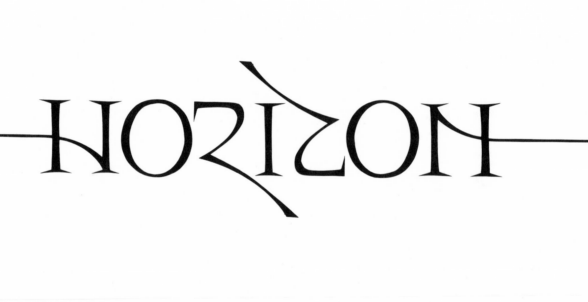

SEQUOIA

dyslexia

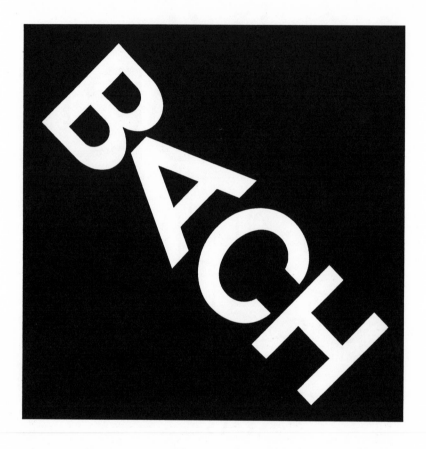

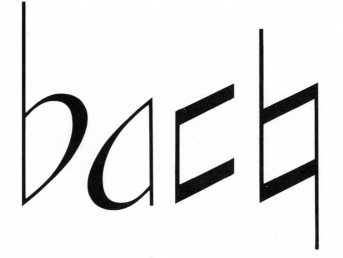

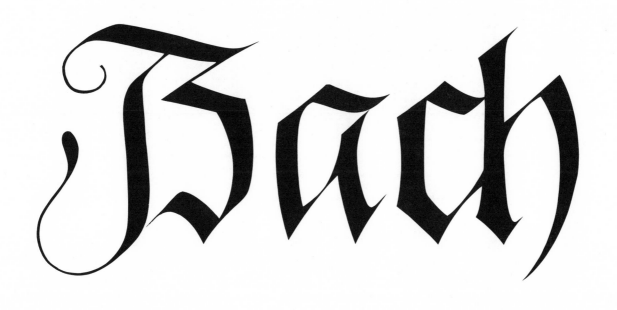

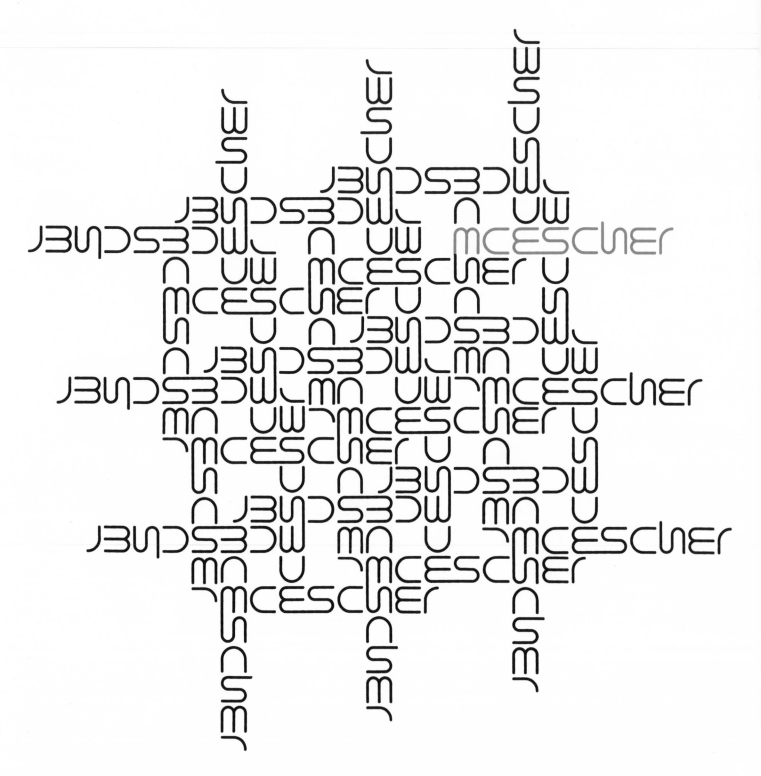

48

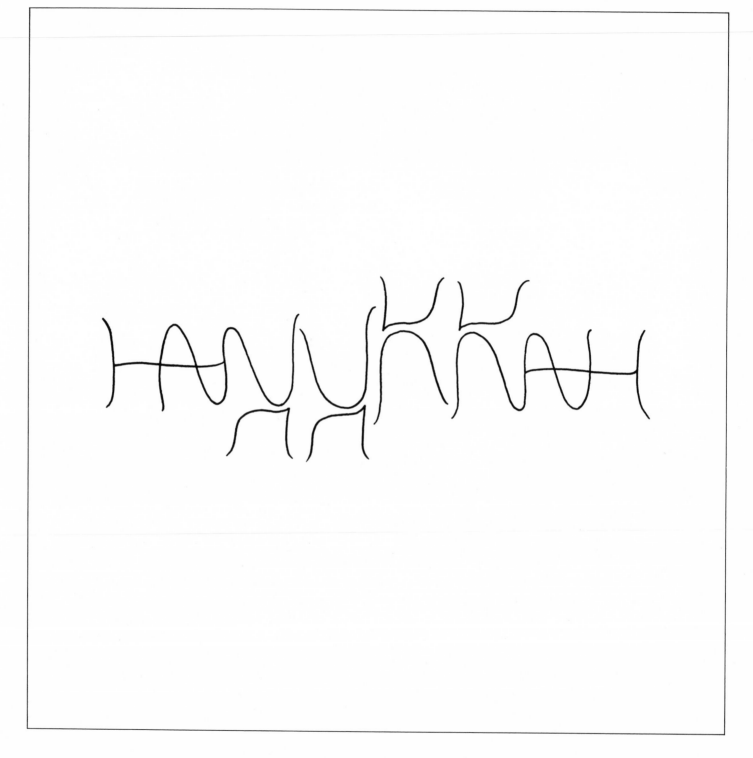

ABCDE
FGHIJK
LMNOP
QRSTU
VWXYZ

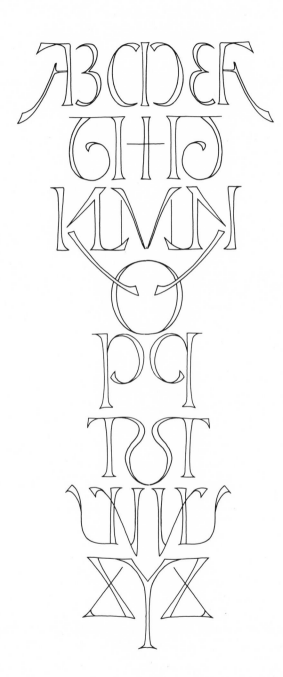

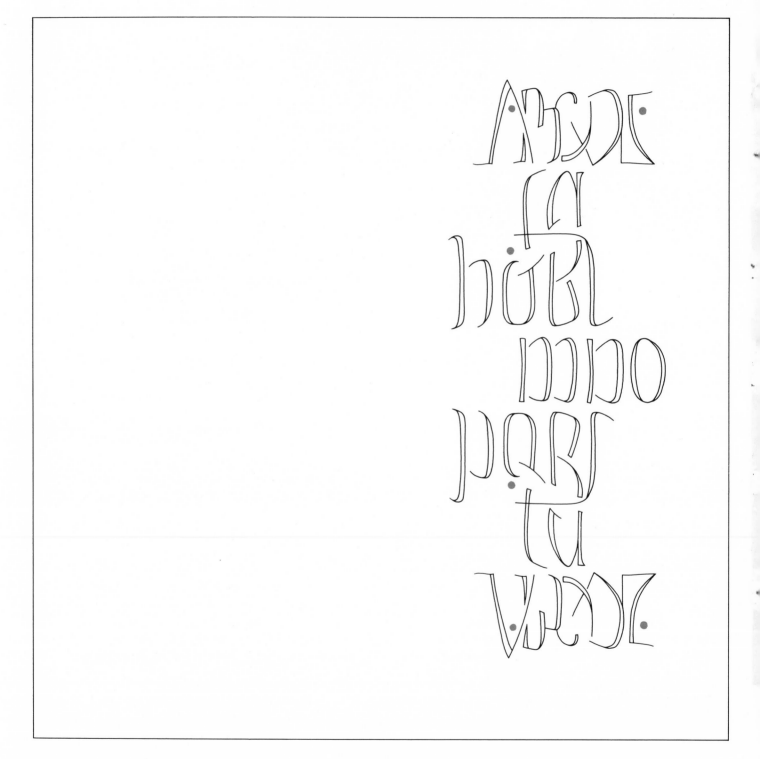

58

martinGardner

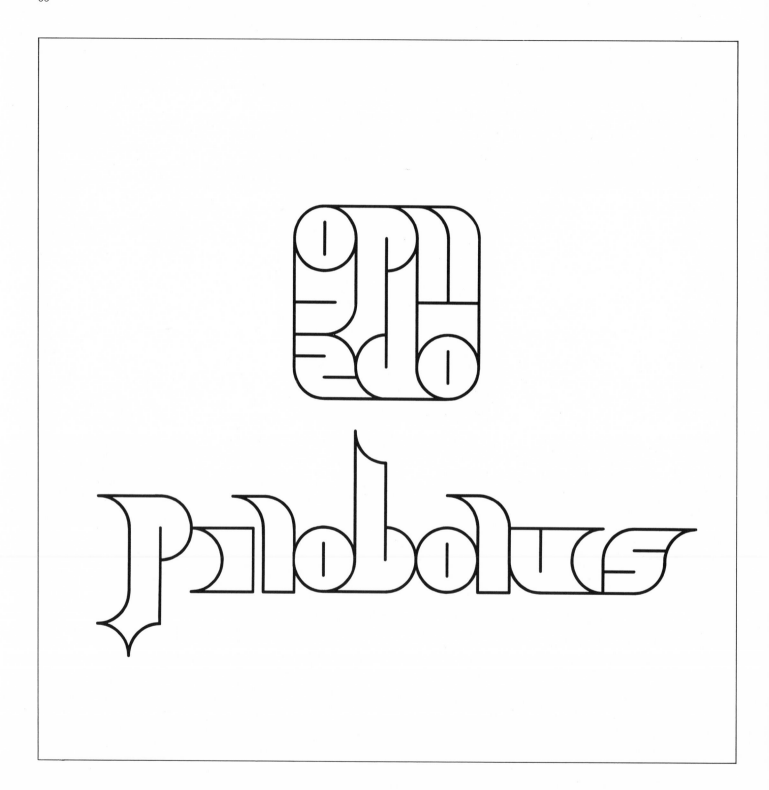

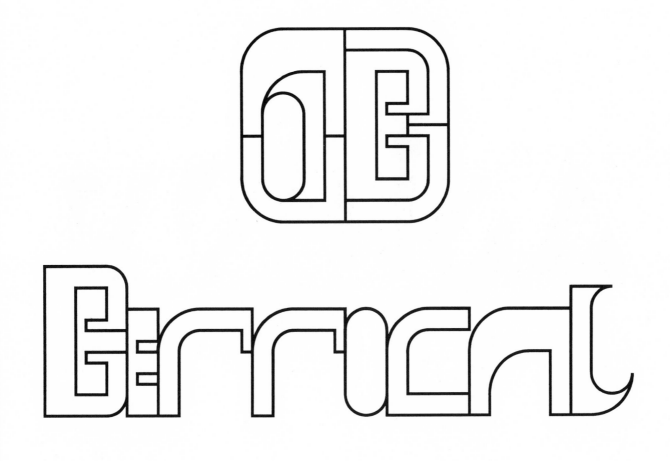

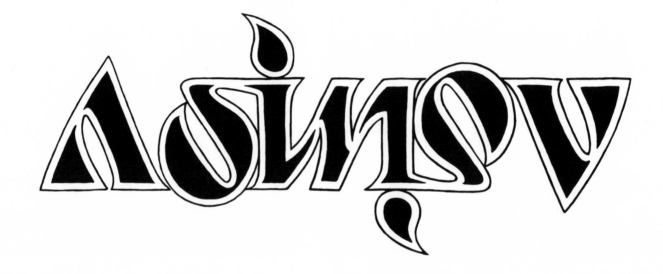

BORGES

mitsumasa

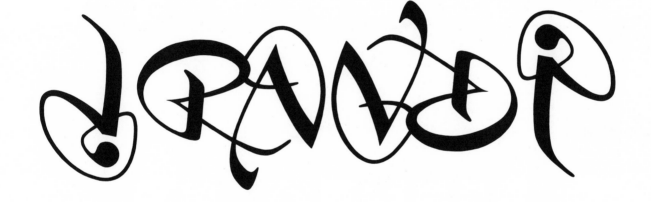

Richard & Gregory

Gutenberg
Gutenberg
Gutenberg
Gutenberg
Gutenberg
Gutenberg
Gutenberg
Gutenberg

rembrandt

Stravinsky

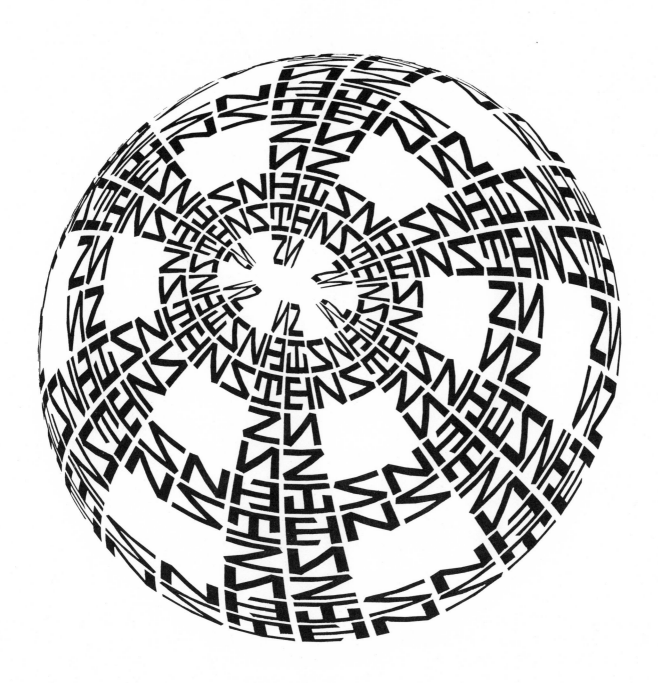

annie

kris

DANIEL

DAVG

Gopdon

Greg

irene

نعمي

kim

leon

michael

naomi

nina

Otto

philip

Roy

RUDY

SOS

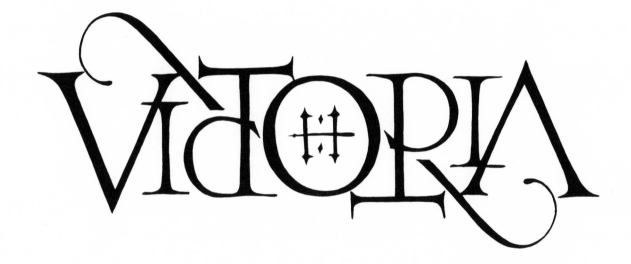

Text

Right	Left
Mano Destra	Mano Sinistra
Right	Wrong
Rectus	Inversus
Dextrose	Levulose
Dextrous	Sinister
Adroit	Gauche
Unity	Duality
Dynamic	Static
Abstract	Concrete
Top down	Bottom up
Right side up	Upside down
Major	Minor
Figure	Ground
Forward	Backward
Symmetry	Asymmetry
Tweedledum	Tweedledee
Positron	Electron
Yin	Yang
Day	Night
Masculine	Feminine
Palindrome	Palindrome
Stressed	Desserts
Open	Closed
Reading	Writing
Perception	Description
Square	Diamond
Upper case	Lower case
Hardware	Software
Discovery	Invention
Horizontal	Vertical
Rectilinear	Diagonal
Straight	Curved
Linear	Multidimensional
Spatial	Temporal
Go	Stop
Green	Red
Adjacent	Complementary
Backhanded	Compliment
Text	Image
Example	Counterexample
Proof	Refutation
Similar	Different
Left	Right

Symmetry

Symmetry, considered as a law of regular composition of structural objects, is similar to harmony. More precisely, symmetry is one of its components, while the other component is dissymmetry. In our opinion the whole esthetics of scientific and artistic creativity lies in the ability to feel this where others fail to perceive it.
—A. V. Shubnikov in *Symmetry in Science and Art*

WHEN YOU SAY that something is symmetrical, how do you mean it? Do you mean it as complimentary in nature? Does symmetry mean everlasting, aesthetically ordered form? Do you imagine diverse unities: the circle, white light, the continuum of time, the cycle?

Does order remind you of elegant harmony or of ponderous monotony? Is it an inventive solution arising naturally out of a problem (suspension bridges)? Or is it mechanical formality for the sake of show (official documents)? Does order evoke the image of a square sitting on a side: unambiguous, unquestionable, stable?

Is symmetry the order within one thing (unity)? Or is symmetry the balance between two things (duality)?

Does balance evoke the image of a square standing on a corner: unresolved, unpredictable, precarious? Is it stubborn opposition for the sake of show (deadlock)? Or is it a flexible adaptation arising naturally out of a process (cooperation)? Does balance remind you of clashing dissonance or of interweaving counterpoint?

Do you imagine universal dualities: yin/yang, black/white, day/night, paired opposites? Does symmetry mean ever-changing, dynamically balanced content? Do you mean it as complementary in nature? When you say that something is symmetrical, what do you mean?

Vocabulary

The strange thing about symmetry is that it is hard to talk about, even though the experience is extremely familiar. Consider the following classical conundrum: Why does a mirror reverse right and left, instead of up and down? If you extend your right hand while standing in front of a mirror, your reflection will extend its left hand—right becomes left. So why doesn't your head become your feet? Take a moment to puzzle this one out. Even if you understand the answer, you will probably have difficulty explaining it to anyone else.

Many people do not understand what the problem is: Left/right and top/bottom are completely different concepts; how can they be confused? Here is a clever variation on the mirror paradox, which may help you appreciate the confusion. Hold the following picture up to a mirror and you will see that the forward *ambulance* is now on the bottom and the backward *ambulance* is on the top. So a mirror does reverse up and down after all. Or does it?

AMBULANCE
ƎƆИAＬUꓭMA

The reason for the difficulty is that most of us rarely practice putting visual and spatial concepts into words. This lack is reflected in our language. For instance, there is no standard word for ʎɐʍ sᴉɥʇ of inverting a word as opposed to ʎɐʍ sᴉɥʇ of inverting a word—not to mention ɥʇᴉɯ ʍɐʎ or yaw siht. Only on special occasions do we need to say consciously what our bodies know, such as when going to a country where the handedness conventions are different.

This lack of words is due to lack of education, not to inherent difficulty. In fields where symmetry is important, a more finely tuned vocabulary has evolved. Photographers talk about flops (left/right inversions) as opposed to reversals (black/white inversions). Actors refer to stage left and stage right, recognizing that the audience and actors have different points of view. Mathematicians studying group theory use the most highly developed symmetry vocabularies of all.

If you want to try designing inversions, you will need a basic vocabulary for talking about symmetry. In order to successfully confuse the viewer, you the artist had best not be confused. To this end, here is a series of exercises that will let you practice thinking about symmetry.

Form and Content	Rule + Module = Result

When you say that something is symmetrical, you mean that it can be described in terms of a systematic *copying rule* (the form) and a basic *module* (the content). Applying the rule to the module recreates the whole. For instance, folding a piece of paper in half and cutting out half a heart creates a whole heart.

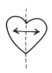

There is another way to think about symmetry. Instead of using the copying rule to build a new pattern, we can use it to analyze the symmetry of an existing pattern. For instance, folding a paper heart in half matches one half to the other. Flipping a heart about its axis of symmetry is another way to match the outline to itself.

Just as a single compositional form, such as theme and variations, may produce many different musical effects, so a single spatial "form", such as bilateral symmetry, may produce many different visual effects. If we apply a single copying rule to different modules, we get different results.

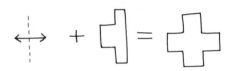

Similarly, if we apply different copying rules to the same module, we also get different results. Here is a halfhearted attempt at reflection, with a horizontal axis of reflection. Notice that when the axis lies completely outside the module, we get a broken heart rather than a whole heart.

The word *symmetry* is usually taken to mean *bilateral* symmetry. There are, however, other sorts of spatial transforms, such as rotation and translation (sliding), that can be used as copying rules. Nonspatial transforms include time reversal and color complementation.

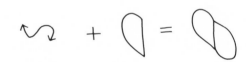

Can you find the module and copying rule that make up this weaving pattern? One possible answer: a square module translated both down and across. But we can do better. Adding reflection to our rule cuts the square in half. The *smallest* module that generates the whole design is called the *fundamental region*.

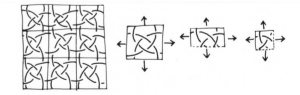

At the other extreme, the *largest* such region is the whole pattern. In this case the copying rule does nothing whatsoever; there is only one copy of the module. Any object can be described as symmetrical from this point of view. As someone once observed, any word at all is the same when rotated 360°.

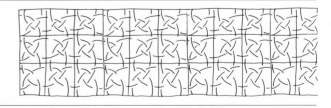

Analysis is only half the story. The other aspect of symmetry is experience. Symmetry is a creature with many forms, which may exist for many different reasons and cause many different reactions. Associations run deep; the presence or absence of symmetry where it is not expected can be profoundly disturbing.

The archetypal experience of symmetry is the human body. Things that occur in mirror-image pairs we tend to classify as left- and right-handed. Society has a strong right-handed bias: The words *gauche* and *sinister* have left-handed roots. The symmetric face is such a primal image that we tend to see faces in anything with bilateral symmetry.

To notice symmetry is to notice relations. Symmetry may be the external relations between a pair of things (hands), or the internal relations within a single thing (a face). If you emphasize the similarities, you see unity. If you emphasize the differences, you see duality. Both are expressed in a single word: complementarity.

Inversions illustrate these two views beautifully. A rotationally symmetric inversion remains the same upside down. Could it instead turn into something else? The answer is yes: Half of a one-faced inversion is a two-faced inversion. Mathematically the two interpretations are the same, but the experiences are opposite.

A hint of symmetry can create strong expectations. The random dot pattern shown here is symmetrical only in its middle region, but we tend to enlarge this perception to include the whole pattern. Our misguided guess relies on the fact that such hints usually imply complete symmetry.

Broken symmetry occurs when something is *almost* symmetrical. Portrait artists learn to see the characteristic differences between one side of a face and the other. Inside, of course, all humans violate symmetry; the heart, for instance, is on the left. In the rare condition called *situs inversus*, the positions of all organs are reversed.

Symmetry can be annoying. The mathematician John Conway invented the term *dilemmatosis* to refer to those familiar, everyday moments of panic such as "Does the knob turn left or right? It was the opposite of what I expected, but what did I expect?" Even the best mathematicians frequently get their signs reversed.

Reflection and Rotation

The two most common symmetries are reflection and rotation. The two are easily confused, since the term *upside down* does not clearly distinguish one form from the other. The ability to distinguish the two forms is not well developed in most people's visual repertoire—an extremely common reaction (mine also) to an inversion with reflective symmetry is to turn it upside down and then be confused when it doesn't say anything.

Reflection is the transformation performed by a mirror. To specify a reflection, we need to give the mirror's position and the direction in which it is facing. We are most familiar with vertically oriented mirrors, which leave people right side up. A horizontal mirror, such as the surface of a lake, turns things upside down. How would you position a mirror so that a standing person appears horizontal?

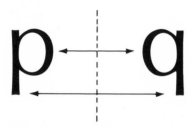

Reflection reverses handedness. When you raise your right hand, your mirror image raises its left hand. Similarly, lowercase "p" when seen in a mirror turns into lowercase "q". Two reflections in a mirror bring the image back to its original form. We call the line through which reflection occurs the *axis of symmetry*. Two-dimensional reflection is also called *inversion about a line*.

Inversion about a line copies each point of an object onto another point at the same distance from the axis, but directly on the other side. If we draw a line between a point and its mirror image, we find that the axis bisects the line at right angles.

Reflection can also be described in terms of rotation. An alternate way to change "p" into "q" is to lift it out of the page, turn it over, and put it back into the page. Turning a two-dimensional shape into its mirror image requires the third dimension; a letter can never be reversed as long as it stays in the plane of the page. Similarly, turning a three-dimensional shape into its mirror image requires a fourth

dimension (whatever that might be). Fortunately, we don't have access to four-space; otherwise, pranksters would be able to maroon us with two left shoes.

We say that an object has reflective symmetry (also called *bilateral* symmetry) if it is unchanged by reflection. The letter "A" is an example of reflective symmetry about a vertical axis. (Actually, the right stroke in a classically proportioned "A" is thicker than the left stroke, but we will consider only an idealized alphabet.)

Words such as CHOICE have complete reflective symmetry. Here are three ways you can check to see that this word is symmetrical: Hold it up to a mirror, place the edge of a mirror against the upper half of the word, or look through the other side of the page. In all three cases the word will be left unchanged. The best way to draw an image so that it will have reflective symmetry is to draw only half the image, then fold the paper in half and trace the other half.

Most large animals, including humans, have bilateral symmetry. Gravity pulls down, so there is good reason for feet and heads to be designed differently, but there is no such motivation for preferring left or right.

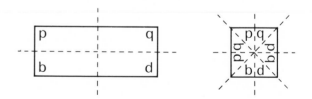

Some objects, like snowflakes, combine both reflective and rotational symmetry. Words are basically rectangular in shape, and rectangles have reflective symmetry about horizontal and vertical axes. Squares, which are more symmetrical than rectangles, remain the same also when reflected about a diagonal axis.

The two most common orientations are right side up and upside down. The two are not easily confused, since one form is usually very different from the other. The ability to tell when the two forms are the same is not well developed in most people's visual repertoire—an extremely common reaction (mine also) to an inversion with rotational symmetry is to turn it over to satisfy oneself that it is the same upside down, then turn it back right side up.

Rotation is the transformation performed by a wheel. To specify a rotation, we need to give the position of the wheel's axis and the angle by which to turn. Rotation, unlike reflection, is a continuous operation. A mirror reflects all at once, whereas a wheel takes time to turn to a new position. A pirouetting ballerina rotates about a vertical axis. Which gymnastic maneuvers spin about horizontal axes?

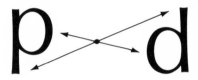

Rotation preserves handedness. When two people extend right hands for a handshake, they are in 180° rotational symmetry. Similarly, lowercase "p" when spun around a wheel turns into lowercase "d". Two 180° rotations about a point bring the image back to its original form. We call the point about which rotation occurs the *center of symmetry*. Two-dimensional rotation by 180° is also called *inversion about a point*.

Inversion about a point copies each point onto another point at the same distance from the center, but directly on the other side. If we draw a line between a point and its handshake image, we find that the center of rotation bisects the line.

Rotation can also be described in terms of reflection. An alternate way to change "p" into "d" is to reflect it twice, once about a horizontal axis and once about a vertical axis. Turning a two-dimensional shape into an image of the same handedness requires multiple mirrors; a letter will always be backward as long as it is reflected only once. If you stand between two mirrors placed at right angles and look directly into the corner, you will see a twice-reflected image that is *not* left/right reversed. A better way to get this effect is to

point a video camera directly at you and face its monitor. It is a strange experience to dress yourself looking into such a "rotational mirror".

We say that an object has 180° rotational symmetry, also called *central* symmetry, if it is unchanged by 180° rotation. In general, an object has $n°$ rotational symmetry if it is unchanged by $n°$ rotation. For instance, a snowflake looks the same when turned 60°. From now on, I will talk only about 180° rotational symmetry. The letter "Z" is an example of central symmetry. (Actually, the lower stroke in a classically proportioned "Z" is longer than the upper stroke, but we will consider only an idealized alphabet.)

Words such as *suns* have complete rotational symmetry. Here are three ways you can check to see that this word is symmetrical: Hold it up to a pair of mirrors at right angles, place the corner of a mirror at the center of the word, or look from the other side of the page. In all three cases the word will be left unchanged. The best way to draw an image so that it will have rotational symmetry is to draw only half the image, then trace the image twice, once each way.

Many microscopic organisms, including viruses, have rotational symmetries. Organisms are closed systems, so there is good reason for internal and external features to be designed differently, but in a floating liquid world there is no such motivation for preferring any particular outward direction.

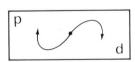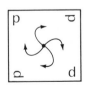

Some objects, like snowflakes, combine both reflective and rotational symmetry. Words are basically rectangular in shape, and rectangles have 180° rotational symmetry. Squares, which are more symmetrical than rectangles, remain the same also when rotated by 90°.

Classification

Inversions can be classified on the basis of three aspects: geometric symmetries, perceptual mechanisms, and other organizing principles.

Geometric symmetries. Rotation is by far the easiest symmetry to use. Other geometric symmetries are somewhat less common. The four basic symmetry operations are reflection, rotation, translation, and scaling.

Reflection changes the handedness of an object and is determined by an axis (mirror). *Rotation* changes the orientation of an object and is determined by a center (pivot) and an angle. *Translation* shifts the position of an object without changing either its handedness or its orientation and is determined by a direction and a distance. *Scaling* changes the size of an object and is determined by a center (vanishing point) and a percentage by which to shrink or expand.

Symmetry operations may be repeated or combined, yielding such patterns as tessellations and recursions.

If you stand between two facing mirrors, you will notice that the even-numbered images are translations of the original—*repeated* reflections about two parallel mirrors yield translations. Translation, unlike reflection and rotation, is inherently open-ended—repeated translation yields an infinite friezelike border pattern. Repeated scaling suggests perspective, an image receding toward some distant vanishing point.

Combining a translation and a reflection creates a *glide reflection,* so named because it combines a glide (translation) and a reflection along the same axis. Footprints in the snow have glide-reflective symmetry.

Patterns that repeat endlessly in two different dimensions, such as tiled floors, are called *tessellations.*

Finally, scaling combined with other symmetries creates *recursion,* in which the images multiply in number as they get smaller.

Perceptual mechanisms. Every inversion can be interpreted in more than one way. In some cases the reinterpretation takes place entirely in the mind of the viewer, while the picture remains still—it is the perception, not the picture, that turns upside down. The four most important perceptual mechanisms used in inversions are: closure, figure/ground, filtering, and containment.

Closure acknowledges that a shape can be seen as either open or closed depending on its context. For instance, a circle with a break on the right is perceived as a "C", but a circle with a break on the left is perceived closed as an "O" since there is no such open letter.

Figure/ground acknowledges that every border line is ambiguous—either side can be seen as "in" or "out". This ambiguity is the basis of Escher's interlocking tessellation patterns.

Filtering acknowledges that the eye systematically ignores (filters out) vast amounts of information in order to see only what it wants to see. The example shown here can be filtered in two different ways. If the squares are filtered on the basis of white and black, the letter "A" emerges. If the squares are filtered on the basis of large and small, the letter "P" emerges.

Containment is a particular application of filtering. By using color to differentiate two parts of a figure, we can give the reader the choice of seeing the whole figure or just one part.

Other organizing principles. Finally, there are other ways of organizing inversions beyond purely geometric or perceptual principles. Other important organizing principles include dissection, symbolism, regrouping, and context.

Dissection is like a jigsaw puzzle. Dissection, like figure/ground, places double meanings on boundary lines, except that pieces are allowed to be moved into a different arrangement.

Symbolism extends the visual vocabulary to include nonalphabetic symbols or even pictures, as is done in rebuses, word painting, and concrete poetry.

Regrouping acknowledges that a scattering of parts can be visually fused into a smaller number of wholes in more than one way. In the example given here, the vertical strokes can be perceptually linked with the bowls either to the left or to the right, depending on whether you want to see "p"s or "q"s.

Context is a catchall for all high-level expectations based on the meaning of the surrounding material. Here the letter "P" is conspicuous by its absence—the order of the alphabet tells us exactly where the letter isn't. This may seem like a far-fetched way to represent a letter, but in fact such forces of habit are what make perception possible.

Geometric Symmetries:

Rotation
Reflection
Translation
Scaling

Geometric Symmetries:

Repetition
Combination
Tessellation
Recursion

Perceptual Mechanisms:

Closure
Figure/ground
Filtering
Containment

Other organizing principles:

Dissection
Symbolism
Regrouping
Context

MNO QRS

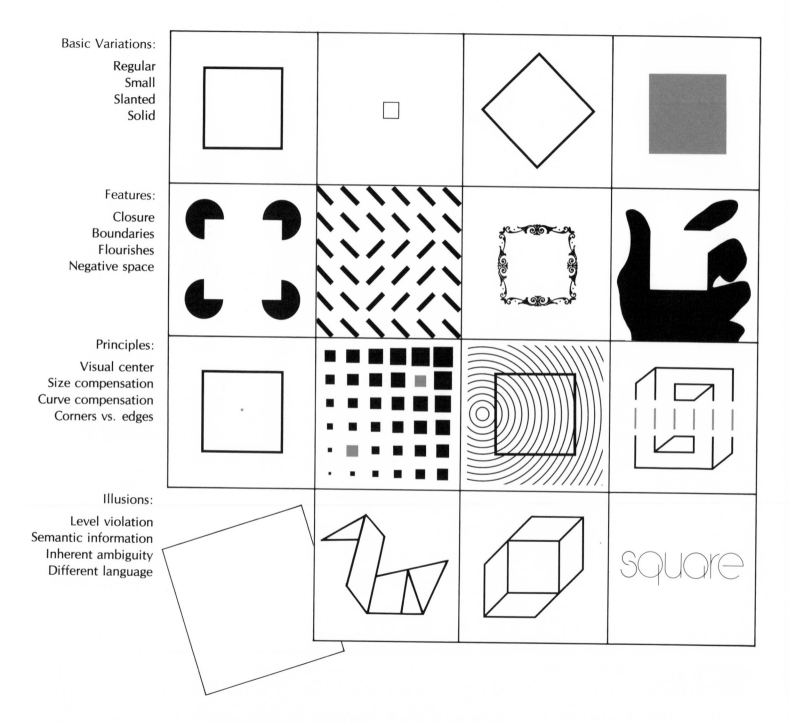

Basic Variations:

Regular
Small
Slanted
Solid

Features:

Closure
Boundaries
Flourishes
Negative space

Principles:

Visual center
Size compensation
Curve compensation
Corners vs. edges

Illusions:

Level violation
Semantic information
Inherent ambiguity
Different language

Vision

There is no better way to begin this book than by trying to see your image in the mirror with something like the wonder and curiosity of a chimpanzee. Imagine that one entire wall of a room is completely covered by a mirror. You are standing in front of this huge mirror, looking straight into it. Exactly what do you see?
—Martin Gardner in *The Ambidextrous Universe*

THE FUNDAMENTAL FACT about seeing is that it is learned. Seeing is in no sense a passive activity. What a person is able to see depends greatly on training—two people looking at the same scene will not necessarily take away the same mental image. Seeing *is* believing, but the beliefs are the creation of the viewer.

The reason we take this extraordinary act of will for granted is that we tend to attribute disagreements to differences of taste, not of perception. Artists, in order to communicate visually, must first become conscious of seeing. Learning to see takes practice and a spirit of inquiry. To this end, here are some exercises and points of view with which to tune your eye.

Square Exercises

Seeing is the process by which an eye extracts information about the world from the patterns of light it receives. When I say "eye", I really mean "eye and brain"—the two are inseparable partners in the process of understanding images. Let us trace some of the steps along the path from eye to brain that make it possible for abstract concepts to be built from simple retinal images.

Seeing is a process of abstraction. At the lowest and most primitive level, light enters the eye. When the upside-down image of a tree hits the back of the retina, however, we do not respond by saying, "I see light hitting my retina." Nor do we say, "The image is upside down." Instead, we say, "I see a tree," or, even more abstractly, "What a nice place to read a book." Artists, who are specially trained in image perception, are more likely than others to pay attention to intermediate levels of abstraction such as color and shape.

Many different retinal images may be identified with the same abstract concept. The four images entitled "Basic Variations" on the opposite page are all seen as squares, even though they differ physically. The first square is

normal, the second is shrunk, the third is tilted, and the fourth is solidly colored.

In some contexts, these differences may matter. If the small square appeared over a lowercase "i", we might call it a dot, ignoring its shape. The tilted square can also be called a *diamond*—a concept different from that of *square*. If the red square appeared in a book of color samples, we would label it as an example of the color red, not as a variation on the concept of square.

The eye, in its pursuit of meaning, enhances certain details and filters out others. The four images entitled "Features" illustrate different ways the eye detects edges and regions. The first image illustrates *closure*. We can hardly help seeing four edges, even though their middles are missing. The eye fills in the missing information in the most familiar way. The second image shows that edges may arise from sudden changes in texture without there being necessarily a change in light and dark. The third image shows that in order to see the bigger picture, the eye may have to suppress finer detail. The fourth image illustrates *figure/ground*—an edge is a separation between object and background, but we can choose to see it either way.

The four images entitled "Principles" illustrate several phenomena of vision familiar to artists. The first image seems to be a square with a dot at its exact center. When turned upside down, however, the "square" reveals itself to be a wide rectangle with a "center" that is too high. In general, vertical and horizontal lines are perceived differently, and visual center is a bit higher than geometric center. The red squares in the second image are the same size; we see them as different because the eye overcompensates for size contrast. The third image shows a similar sort of overcompensation, this time for curvature. The fourth image illustrates that most of the information in a picture is found in the borders. This is why a line drawing consisting of nothing but borders can still be seen as a solid figure.

As the brain forms more and more abstract images of what it is seeing, the opportunity for confusion increases. The four images entitled "Illusions" call attention to loopholes in our knowledge of the visual world. The first image abruptly makes us aware that we have been seeing squares all along as frames. The second image is hardly a conventional square, yet anyone who knows origami will immediately recognize that this is a picture of a folded square. The next image emphasizes that ambiguity is an inherent aspect of interpretation, especially with images of three-dimensional objects. There is nothing about a picture of a transparent cube that says which way is in and which way is out. The final image jumps out of the system to an entirely different language. This is perhaps the most subversive image of all.

Letter Exercises

Reading is the process by which an eye extracts information about the world from the patterns of letters it receives. When I say "eye", I really mean "eye and brain"—the two are inseparable partners in the process of understanding symbols. Let us trace some of the steps along the path from eye to brain that make it possible for abstract words to be built from simple retinal images.

Reading is a process of abstraction. At the lowest and most primitive level, light enters the eye. When the upside-down image of a page of a novel hits the back of the retina, however, we do not respond by saying, "I see light hitting my retina." Nor do we say, "I see a lot of 'e's." Instead, we say, "I'm reading a novel," or, even more abstractly, "What a nice occasion to enjoy the shade of a tree." Copy editors, who are specially trained in letter perception, are more likely than others to pay attention to intermediate levels of abstraction such as spelling and punctuation.

Many different retinal images may be identified with the same abstract letter. The four images entitled "Basic Variations" on the opposite page are all seen as the letter "A", even though they differ physically. The first letter is normal, the second is changed to lower case, the third is set in italic, and the fourth is seen in outline.

The eye, in its pursuit of meaning, enhances certain details and filters out others. The four images entitled "Features" illustrate different ways the eye detects letters and words. The first image illustrates *closure*. We

can hardly help seeing a capital "A", even though the thin stroke, called a *hairline*, is missing. The eye fills in the missing information in the most familiar way. The second image shows that distinct letters may arise from a uniform texture without there being necessarily a physical separation. The third image shows that in order to see the bigger picture, the eye may have to suppress finer detail. The fourth image illustrates *negative space*—the spaces between and within forms are as important as the forms themselves in seeing shape. Distribution of negative space is a major factor in the determination of letter spacing.

The four images entitled "Principles" illustrate several phenomena of vision familiar to type designers. The letters in the upper half of the first image seem to be symmetrical. When turned upside down, however, they reveal themselves as significantly heavier on the bottom than on the top. Furthermore, the vertical strokes of the "H" need to be drawn thicker than the horizontal strokes in order to appear visually equal. The top of the "A" and both the top and bottom of the "O" in the second image extend beyond the boundaries of the other letters; we see them as even because the eye underestimates the position of a rounded or curved edge. The third image shows a similar sort of compensation—the italic letter "f" is usually tilted back a little to prevent it from visually falling forward. The fourth image illustrates that most of the information in a letter is found in the upper half. When the eye reads a line of text, it rides along the upper edge of the lowercase letters. This is why the letter "i", during its historical development, acquired a dot on the top, not on the bottom.

As the brain forms more and more abstract images of what it is reading, the opportunity for confusion increases. The four images entitled "Illusions" call attention to loopholes in our knowledge of the alphabetic world. The first image abruptly makes us aware of the power of sentences to refer to themselves. The second image is hardly a conventional word, yet anyone who knows *origami* will immediately recognize that this is a picture of a folded word. The next image emphasizes that ambiguity is an inherent aspect of interpretation, especially with the grouping of parts into wholes. There is nothing about the central symbol that says whether it is a number or a letter. The final image jumps to an entirely different language. This is perhaps the most subversive image of all.

				Basic Variations:
A	a	*a*	A (outline)	Regular Lower case Italic Outline
A (reflected)	minimum	(flourished A)	sisoace (negative space)	**Features:** Closure Letter boundaries Flourishes Negative space
SHSHSH HSHSHS	**ABOVE**	*infinity*	Film / mliƎ	**Principles:** Visual center Overshoot Slant compensation Upper half vs. lower half
This sentence is upside down. (upside down)	ORIGAMI	12 ABC 14	A □ has four sides.	**Illusions:** Level violation Semantic information Inherent ambiguity Different language

91

A B C
D E F G H
I J K K M
N O P Q R
S T U V W
X Y Z

Letterforms

There are three sacred goals:
love the pen, love writing, love the book.
—Sayat Nova

OURS IS A literate culture. Every day we are besieged by a frenetic mob of printed words, in all shapes and sizes, screaming for our attention. We rely on words for our news, we share experiences by writing letters, we even use words to talk about words themselves. Why is it, then, that we so seldom pause to ask how and why the forms of our letters came to be? In this section I will outline the sorts of questions that every letter-recognizer should wonder about.

Reading

We learn at a very young age to read the 26 letters of the alphabet. Recall the time you learned to read. Did you ever wonder how the capital and small letters were related? "S" is just a large "s", but why do we call "G" and "g" the same letter when their shapes are so different? I remember being personally offended by the ugliness of the cursive "Q".

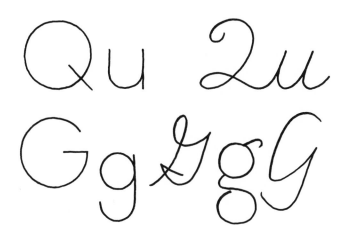

Printed "Q", with its long, flowery tail, I appreciated, but how dare the numeral "2" intrude into the alphabet! Cursive "G" and typed "g" present similar mysteries. The cursive "G" taught in Europe offers yet another possibility.

Printing technology has spawned many new interpretations of letter shapes. Look around at the alphabets in books and signs. If you think you understand what they all have in common, just try explaining how to recognize the letter "G" to a non-Roman-alphabet-using person. Can you explain it without using pictures? Conversely, a single shape may serve as many different letters, depending on its context.

The point I want to impress upon you is that there are literally thousands of different graphic forms that we recognize as a single abstract letter. There are many more than 26 letter*forms* in the English language. Ultimately all scripts have a single ancestor—the Roman capitals—but such forms as upper and lower case have diverged so far that they deserve to be called separate scripts.

What a curious development this double alphabet is! Chinese, for instance, has no such separate uppercase script. What is most remarkable is that we take this visual multiplicity in stride and don't even pause to notice the tremendous leaps of adaptation our eyes have to make.

One of the most intriguing aspects of visible language is that it presents so many levels of structure, all of which communicate simultaneously. Strung together, letters become words, words become sentences, sentences become paragraphs, paragraphs become chapters, and chapters become books. Each level has its own way of making its presence known—words are marked by spaces, sentences are marked by initial capitals and final punctuation, paragraphs are marked by indentation or blank lines, chapters are marked by titles, and books are marked by covers.

Sometimes one level affects another. Renaissance scribes trying to form consistent right-hand margins often stretched the last letter to fill the remaining space— the letter was violated to accommodate the line. An alternate approach is hyphenation—the word is violated to accommodate the line. Sometimes text must be rewritten to fit—all levels are violated. Printers trying to avoid "widows"—the worst example being when the last word of the last sentence of the last paragraph of the last chapter of a book is hyphenated onto the last page—may readjust spacing at any one of a number of lev-

els.

Writing

We learn to write the 26 letters of the alphabet at a very young age. Recall the time when you learned to write. The tool you used probably had a large effect on your experience. If you began with a fat pencil on widely lined, brittle paper, you learned that letters were enormous blobs that were prone to straying outside the lines. Writing required frequent trips to the pencil sharpener. If you began with a dip pen, you learned that letters were messy and prone to blobbing, smearing, or running out of ink. If you began with a typewriter, you learned that letters were tiny symbols all the same width, available in red or black, and prone to jamming. If you began with a computer terminal, you learned that letters were made of luminescent dots, easily lost, and a means for picture drawing, game playing, and two-way communication.

The same effect applies to other writing tools. Writing with a quill pen makes one vastly more sensitive to the quality of the paper and of the ink. The care with which the quill must be maintained makes writing much more of a deliberate, refined process. Chiseling in stone requires even more advanced planning, since the medium of stone is far more permanent than paper. Writing with a brush turns the activity of making lines into a dynamic three-dimensional performance akin to dance.

The same effect applies to letters in books. The invention of movable type totally changed attitudes toward literacy. At first the printed book attempted to mimic the handwritten book—Gutenberg's typeface was directly based on contemporary scripts—but soon it established a logic of its own. Printing made the book a repeatable, transportable commodity, which made tangible the classical ideal of linear order.

Printing technology has lent many new words to the English language. The term *font*—which refers to a complete alphabet, including lower case, upper case, numbers, and punctuation—comes from the same root as *fountain* and *fondue*, and refers to the foundry process of melting hot metal. The terms *lower case* and *upper case* refer to the physical drawers of metal type used for hand-set type. The word *print* itself refers to the act of pressing physical type against paper.

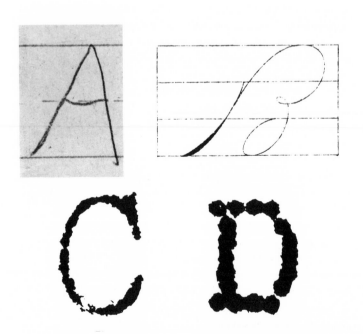

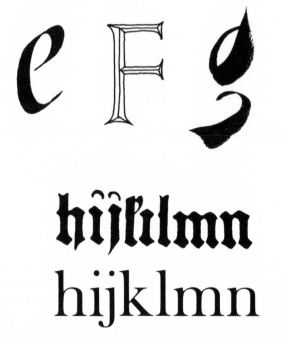

SS TT

uuuuuuuuu

VVVVVVVVV

WXYZWXYZ

The point I want to impress upon you is that there are literally thousands of different tools that we can use to make the same graphic letterforms. The classical Roman alphabet, from which all of our scripts evolved, was based on the thick and thin lines naturally produced by a wide brush. You can imitate this effect by binding two pencils together so that they draw a double line. Most calligraphic scripts keep the pen at a fairly constant angle of about 45°/sloping up to the right—this is why the letter "O" in many older typefaces seems to tip to the left. Recreating the elegance of the Roman capitals is a real test of a calligrapher's skill. The Romans had no small letters. The minuscules (small letters) evolved from the Roman majuscules (capitals) over many centuries as scribes sought shapes that were more suited to the movements of the broad-edged pen.

What a curious development this double alphabet is! Chinese, for instance, is based instead on brush forms. What is most remarkable is that we take all this visual logic in stride and don't even pause to notice the tremendous body of conventions our eyes have assimilated.

One of the most intriguing aspects of visible language is that it records so many levels of influence, all of which communicate simultaneously. When we see a letter we are seeing its history, the biases of the writing tool, the character of the recording medium, the role of language in a society, the prevailing visual aesthetic of the time, the logic of the other 25 letters, the overall effect intended by

the designer, and the visual requirements of the eye. Each level has its own way of making its presence known—the way characters are built up is influenced by the interaction of tool and medium, character shape is influenced by visual considerations, character sequence is influenced by grammar and the message of the author, and page layout is influenced by visual aesthetics.

Sometimes one level affects another. At the lowest level, the idiosyncrasies of vision demand that subtle shape adjustments be made in order for a typeface to be perceived correctly. For instance, the top half of an "S" is smaller than the bottom half, and the crossbar of a "T" is thinner than the vertical stroke.

Visual demands can also work against legibility. The Gothic visual aesthetic molded writing into an almost illegible blur of peaked vertical lines. Legibility gave way to overall texture. The dot was invented to rescue the Gothic "i" from complete indistinguishability.

Serifs (the little spurs at the ends of strokes) originated as characteristic motions of the broad pen. In typefaces, they serve to guide the eye along horizontal motions. Contemporary typographers favor sans-serif ("without serif") fonts, whose clean lines are in keeping with a functional, unembellished visual style.

Each new writing tool offers both new freedoms and new limitations. It will be interesting to see how the merging of communication and computer technology will influence the evolution of letter shapes.

Design

The best way to probe the limits of letterforms is to experiment. Working under different constraints produces characteristically different solutions. The alphabet on the opposite page samples the sorts of letters I was led to design in the course of preparing the inversions in this book. Many of these forms I never would have considered as letters under other circumstances.

Invent a 27th letter of the alphabet. Design versions of it to match existing typefaces. Remember that it must be different enough from the other letters that it does not cause confusion, yet similar enough that it does not look out of place.

If you had a chance to invent your own alphabet from scratch, what would you do? How would you judge the success of your design? Korean and Armenian are prime examples of scripts that resulted from deliberate invention, rather than from natural evolution. Would your alphabet have looked different if your native language had been Polish? What other possibilities could you consider?

Gain new perspectives on the reading and writing skills you already have. Try reading a book upside down. Try writing while looking only at the mirror image of your hand. Try writing so that the mirror image reads normally. Try writing with your other hand. Try writing with both hands simultaneously in contrary motion. Try writing with a pencil in your toes. Try writing blindfolded. Try writing behind your back. How do these experiences differ from normal writing?

Try making letters in radically different media. Draw 20-foot letters with a stick on a beach. Bake a cake in the shape of a letter. Signal letters with your hands. Form the shape of your name with your body (you may have to enlist the help of friends). Invent a three-dimensional alphabet that assembles into sculptural words and sentences. Make an alphabet of partially eaten pretzels. Find letters in close-up photographs of butterfly wings.

Pursue graphic themes. Write a word in one continuous line without lifting your pencil. Connect letters in unexpected ways. Design an entire alphabet that is derived from different arrangements of a very small number of different shapes. Make letters entirely out of circles. Produce alphabets that create strong textural effects based on different perceptual mechanisms. Draw a letter so that it clearly expresses a concept that begins with that letter. Design a signature that expresses who you are. You might even want to try writing words that read the same upside down.

Observe an existing typeface. Which letter is your favorite? Which letters, if any, stand out as inconsistent? What is the underlying idea that unifies all letters? How can the idea be generalized? What happens if the style of one typeface is mixed with the style of another?

An excellent way to gain insight into the problems of type design is to cover up one letter of a newspaper headline and then try to reconstruct the missing letter on the basis of the style of the other letters. You will soon find that the task is not so simple. The inverse problem is even more interesting: Generalize a single character to create a whole alphabet. Try this with a friend and compare results. How do your assumptions differ?

Type design must be approached as a unified problem. The type designer considers the alphabet as a community of interrelated shapes—shapes that are understood in terms of each other and in terms of the traditions of letterform design. A good type design must survive the rigors of the printing process, serve the intended functions (who will read it? under what conditions?), compensate for the peculiarities of human vision, and at the same time express a coherent aesthetic message.

One of the most important facts a letterform designer must realize is that the reading eye takes in whole words or groups of words at a time. Letters should blend harmoniously into easily recognized word shapes. For this reason, a word set in lower case (which has both ascenders and descenders: strokes that go above and below as in "b" and "q") is read more easily than the same word set entirely in upper case. In fact, if the overall shape of a word is correct, individual letters can be distorted or even left out without affecting legibility. This triumph of word over letter is an excellent demonstration of the power of context, and is one of the most important principles to remember in the design of inversions.

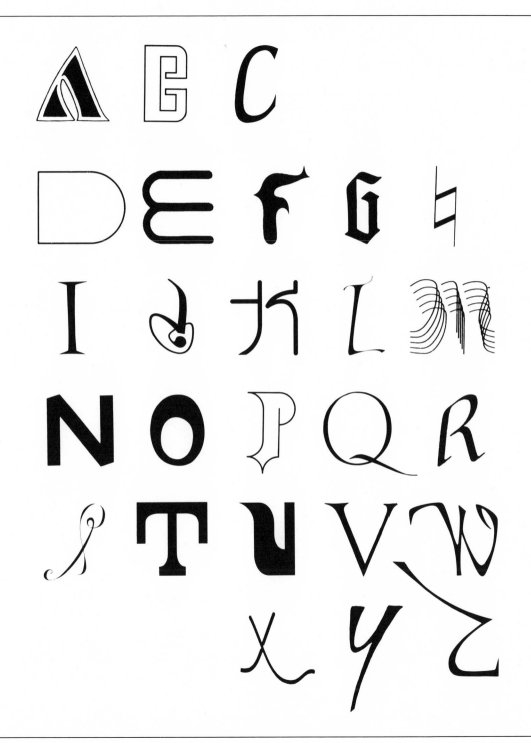

MAURITS
ESCHER

HUGO

CORNELIS

JSBACH

BACH

JS Bach

Johann
Sebastian

Bach.

JSB

JSB

JSB

bach

Center: .initdc
0 0 0 .color
30,300 .translate
16,16 .scale

#JSB:
#J 9,4,0 .translate
#S 10,0
#B 10,0

1.1,-2
8,-.8 1,-3
8,22.5 -1,-.1
1.5,23 -5,1

6,23 -4,-3
1.2,20 -2,-1
X = 6,-9
X 6.2,18.6 2,1
 = 1,-4
-X 6.7,10 0,-1
 4.5,1.3 -1,-2,1
-X = -1,1.4
-X 5,8 -7,1.8
 -3,7 3,-4
 5,-4 2,-3
 = 1,2
 8,10 1,10
 8,18.3 -1,10
 3.7,20.4
 7,22.2
 6,23

X -3,22.5 1,-30
1,2.0 -1,50
5.7,0 1,2
9,8 5,16
9,5,11 0,1
7.2,17.9 -1,2
2,17.5
1,6,17
6,8,17.2 1,-2
8,9,9.5 0,-1
8,17 -1,-3
5,9 -2,-3
1.4,1
1.3,21.6
= 10,1
6,4,21.5 10,-1
5.8,19.1
6,18.1 1,3.1
7,21 1,2.7
6,22.5
-3,22.5

1.5,23
2,21.7 6,1
6.5,22 1,10
8,18.3 -1,10
7,7 0,-1
= -1,1.9
2.2,18 -9,2
= -1,-2
-3,8 0,-1
2,-2 1,-2
7,-8.5 1,-1
7.9,-8 -3,2
X 2.5,-2 -1,2
0.8 0,1
1.9,17 1,2

Processes

This book discusses the inversion transformations
and their applications.
—I. Ya. Bakel'man in *Inversions*

DESCRIBED HERE are some of the steps I go through in designing an inversion. Most of the principles will arise naturally once you get started, and certainly there are other approaches. I hope that these examples will encourage you to go exploring on your own.

Before

An inversion is an exactly symmetric design based on a word or name. The challenge is to somehow satisfy both legibility and symmetry in a manner appropriate to the meaning of the word. To juggle symmetry, legibility, and meaning can be a precarious task. The inversion designer must have a good sense of balance in order to maintain all these different qualities, for inversions require not only a sense of visual balance, but a sense of conceptual balance as well.

Before I start into the description of the working-out process, I would like to emphasize several points.

1. Words are not normally symmetrical (aside from an occasional palindrome). In the section that follows, I present the design of inversions as if it were a feat of systematic deduction. In reality it is nothing of the sort. Inverting a word is fundamentally a totally unreasonable task. Legibility and symmetry are under no obligation to cooperate. The alphabet was not designed with inversion in mind.

2. Symmetry must be followed exactly. Certainly symmetry of lesser exactness is also interesting, but the point here is to find a way to work within the rules. Successful inversions work with, rather than against, the exactness of the symmetry.

3. Letters can be "stretched" in many different dimensions and remain legible. Without this flexibility, inversions would not be possible. The fact that people are highly skilled letter-recognizers gives the inversion designer endless means of expression to work with. It is indeed fortunate that we have such a rich domain to play in.

Here are some principles to keep in mind when approaching inversions.

1. Aim for consistent style. Visual unity is the force that binds the elements of an inversion into an ordered composition. Remember that, while all levels are important, it is usually true that the word is more important than the letter, the letter more important than the stroke.

2. Aim for resonant meaning. Always work toward a design that will communicate at many different levels, even though you may not know initially how to get there. Many of my inversions started with a complete challenge: Wouldn't it be nice if the word *symmetry* could be written symmetrically? I don't always meet my original challenge, but the pursuit is always rewarding.

3. Be flexible. You are the one setting the goals; if you can't find a solution, consider changing the problem! There are endless varieties of symmetries and lettering styles to draw from. If legibility is suffering, drop symmetry altogether and concentrate on making beautiful letters. Don't expect that every approach will work. I don't find solutions for the majority of the words I try. On the other hand, don't give up too soon. New ideas often take unexpected turns.

4. Observe. Determining that an inversion is possible may take only a few minutes; refining it so that it communicates clearly takes a willingness to observe people's reactions to what you have done.

99

During

Here is the history of the inversion **ANNIE**.

1. First, choose a word to work on. I enjoy choosing words that mean something special to me. The word may be only a few letters long, or it may be a full name or phrase. Your own name is a good choice. Print the word in ordinary handwriting. Observe the letters—do they suggest any particular symmetries? A few words, like **NOON**, are naturally symmetrical, but most words do not reveal their symmetries so easily. Finding a solution requires imagination, persistence, and faith that a solution just might lie waiting to be discovered.

2. A good way to begin the search is to print the word again, inverted, just below the original. Compare the two words letter by letter. Do the letters have any shapes in common? If you are skilled at visualization, you may be able to do this in your head, but seeing the actual word in front of you is always helpful. As you become more experienced, you will begin to see some of the same letter combinations returning over and over.

3. Suppose that we have decided to invert the name **ANNIE**. Notice that the middle **N** is the same upside down—perhaps it can serve as a pivot for rotational symmetry. Can we find a way to extend this symmetry to the rest of the word? In other words, is there a way for **AN** to invert to **IE**? We could also choose to start with **NN** as the pivot, or to work from the outside in, starting with a way to turn the initial **A** into the final **E**.

4. What usually happens is that a couple of letters will invert easily but the rest stubbornly refuse to follow the pattern. This is where imagination comes in. If uppercase **A** will not invert to uppercase **E**, try using lowercase letters. If lower case doesn't work, try cursive. The key here is to experiment. There are many ways the letter **A** can be drawn. If your imagination gets stuck, look in a book or magazine to see how other people have drawn it. It is always surprising to see what new shapes have been called upon to serve as letters.

5. A standard variant on rotational symmetry is to put the center of rotation somewhere other than the center of the word. Off-center rotation forces you to repeat the word indefinitely, or to leave the final occurrences incomplete. Both possibilities are illustrated by **INFINITY** (pages 32-35).

6. If a particular combination really doesn't want to work, perhaps there is a way to avoid the problem altogether. Sometimes it is best to switch to an entirely new symmetry, rather than try to repair the old one. Other times it may be best to keep the basic symmetry but switch to a new word. After all, there is no guarantee that the problem either has or does not have a solution. Even when you have found a solution, always remain open to new approaches. You may be surprised. In preparing the examples for this chapter I found several new solutions to **ANNIE**.

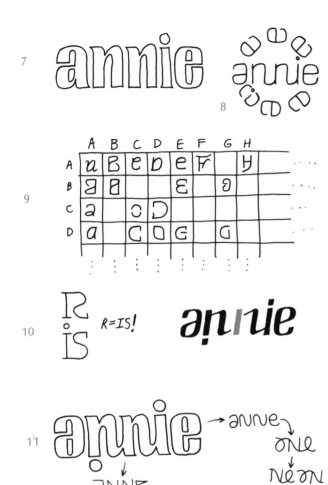

help establish the style of visual presentation. For instance, **ANNIE** was originally designed for the Annie awards, the animator's equivalent of the Oscar, so perhaps elements of motion could have been incorporated.

9. One of the most useful techniques to master is letter regrouping. At first glance, it may appear that all one has to do to invert a word is to first make a big chart with every possible pair of letters, showing how each letter can be designed to invert to any other letter. It is then just a matter of applying the chart mechanically to the word. The first letter would then match the last letter, the second letter would match the second-to-last letter, and so on until we reach the middle, where we find either a single letter that matches itself, or (if the number of letters is even) two neighboring letters that match each other.

10. At second glance, it becomes apparent that this is not always what happens. For instance, in the up/down symmetric version of **MERRY CHRISTMAS** (p. 51), **MERRY** has five letters, while **CHRISTMAS** has nine. Yet both are composed of exactly the same shapes. Where do all the extra letters come from? The answer is that letters do not necessarily invert one to one. A letter inverted may turn out to be only *part* of another letter. Or it may turn out to be two or more letters. Shifting of letter boundaries in this manner allows great freedom in designing an inversion. Notice that the central downstroke in **ANNIE** always serves as the left side of the lowercase "n", even when turned over. The center is no longer a particular letter or pair of letters, but a stroke that may be seen as part of a letter in two different ways.

11. The best way to incorporate an awkward letter shape is to find a style in which it appears natural. The awkward aspects then become rationalized as "part of the style". I cannot stress enough how powerfully legibility and overall coherence are enhanced by a consistent style. In fact, style usually emerges as a result of the demands of the problem.

12. Extending the effects of the style to the rest of the word may suggest new ways of looking at the other letters. This may in turn suggest new styles, which suggest yet other ways of looking at the letters, and so on. So difficult combinations, rather than acting as "problems", sometimes act as the energy source that propels the search for solutions.

7. Sometimes all it takes is putting the problem aside and returning later with a fresh point of view. Forget the symmetry for a moment and draw the word according to purely typographic standards. How can that quality be preserved in the presence of symmetry?

8. Personal names offer considerable flexibility. If *Annie* doesn't work, try another form like *Anne* or *Annette*. If that doesn't work, try including the last name or initial. You can also try combining names of two different people. Always keep in mind the character of the person—it may

After

Through inversions I have explored many paths in the worlds of problem-solving, symmetry, vision, letterforms, and illusion. Here are some reflections on what I have learned in the process.

I was infected very early with the romance of the alphabet. I have always enjoyed all aspects of reading and writing. One event I will never forget was a project in second grade in which we made inkblot patterns out of our names. To begin with, we wrote our first names in cursive on a line that divided the paper in half vertically. Then we folded the paper along the line, and traced what we had written on the other half. The resulting bilaterally symmetric patterns had a strong tendency to suggest animal shapes—mine looked like a flying insect with capital "S"s for wings, "o"s for eyes, and "t"s for antennae. Coloring in the line drawing completed the leap from seeing letters to seeing shapes.

Words are the primary visual symbols we use to describe the world. Learning to appreciate the history of the alphabet would therefore seem to be a high priority. There is so much to be learned from playing with letters—why isn't more of this taught in schools? These days, few people are aware of typographic principles, let alone that some people devote their lives to this profession.

One thing every letter-maker learns is how much power there is in a name. Inversions make outstanding gifts—even if it is only a first name, the receiver immediately identifies it as something personal. Creating a design on your own name can be a powerful exercise in defining your own identity. Designing with letters not only helps make you aware of how letters affect you; it opens your eyes to the whole range of visual experience. It allows you to practice seeing, to experiment and learn from feedback.

The English language is read left to right in horizontal lines. Other possibilities include Hebrew, which is written

right to left, and Chinese, which is written top to bottom, right to left. Ancient Greek writing followed *boustrophedon,* a rebounding pattern in which alternate lines proceed from left to right, then right to left reversing not only the order of the letters, but the letter shapes themselves. The word has the same root as *bovine,* and derives from the image of an ox plowing a field in a "forth-and-back" manner. Some computer-driven printers are designed to type in this pattern in order to save the time of a carriage return. The end result, however, unlike true boustrophedon, does not contain mirror-reversed letters.

It is worth pausing a moment to wonder at the asymmetry of written language. Why do shapes look so different in different orientations? Why do books become increasingly difficult to read as they are rotated away from upright? Certainly the bias is learned—nursery school teachers hold their books upside down when reading to their classes, so that the children can follow along. Which do you find more difficult, upside-down reading or mirror reading? Hold this book to a mirror and you will find that the whole texture of the page, not just the individual letters, runs the wrong way. Nature has no such bias. The only way to tell if a photographic transparency has been flipped is if there is something artificial in the scene, such as a written word.

I receive many sorts of reactions from a new inversion. All of these reactions are equally legitimate and illustrate the vast range of expectations with which one may approach the written word. People who enjoy working out puzzles immediately recognize a challenge. They often prefer words they have to work at to read. People with backgrounds in lettering often have the opposite reaction. Legibility is the main issue for them.

Some people read the word at once, but on closer examination decide that the individual letters are not legible after all—a most curious backing off. Other people get stuck on individual letters and never see the whole word. My usual advice to someone in this position is to hold the

word farther away and try to take in the whole picture at once. Then there are those for whom playing with letters is an alien idea, one that makes them very uncomfortable. At the opposite extreme are people who have come to expect *everything* I show them to turn upside down!

There is admittedly a certain artificial or arbitrary quality about the combination of lettering and symmetry. Why should a designer have to suffer under such severe limitations? My answer is that working within the limitations of pure symmetry is an excellent means to new discoveries. Like canonic imitation in music, symmetry in inversions serves as a compositional device. Symmetry *per se* is not the goal. Instead, it provides a simple, precise set of rules that help to structure the compositional process. Symmetric structures also give viewers an entry point into the composition—they can participate immediately by hunting for the type of symmetry used. Hopefully there will be more left to find once the symmetry has been fathomed.

The success of an inversion, like that of any formal composition, depends on the appropriateness of the form to the content. Ideally, form and content should support each other in a way that makes it difficult to tell which came first. In such a case, the viewer is left with what seems like an inevitable conclusion, without a clue as to where to begin reconstructing its derivation. Isn't it an amazing coincidence that *symmetry* can be written symmetrically?

Misdirection is what makes such illusions possible. Magicians create the illusion that they are performing the impossible by showing you only what they want you to see. By encouraging your expectations to leap ahead of your evidence, they lead you to draw impossible conclusions that are, nonetheless, difficult to deny.

In the case of inversions, the final result hides all the failed attempts, the partial solutions, the unexplored alternatives. Your mind reacts immediately to the expectation that it is about to read a word. Only after you have recognized the word can you begin to analyze how it was constructed, and by then you have already narrowed your field of vision down to the premises that made the inversion possible in the first place. Why does rotational symmetry fit the word *symmetry* so well? The answer is that if it hadn't, I wouldn't have shown it to

you—and you would never have gotten a chance to ask the question!

I should hasten to add that the ability to be fooled does not imply foolishness. On the contrary, it is *because* we are intelligent that we have perceptual expectations, and therefore jump to conclusions that may, in certain contrived circumstances, turn out to be untrue.

My favorite reaction to inversions, the one I strive for, is simple delight. There is something enchantingly paradoxical about being confronted with an undeniable impossibility, especially when the impossibility occurs in a familiar domain such as the written word. Periodic encounters with such absurdity I find most revitalizing to my sense of wonder.

When I was a child, magic fascinated me. I learned very young just how powerfully people's attention can be misdirected. The only problem was that I always wanted to explain how the tricks were done. I wanted everyone to see how they were being fooled. To understand the mechanism and still be entranced—that to me is the greatest magic. That is what attracts me most to inversions.

I have always enjoyed illusions. Certainly there is pleasure in having your senses tickled, but illusions also serve a deeper purpose. Illusions are not mere sleights of hand, but singular revelations of inconsistencies that are *inherent* in your perception of the world. Illusions are *sleights of mind,* for to perceive is to know.

The perceptual/cognitive scientist Richard L. Gregory, in *The Intelligent Eye,* summarizes this point of view beautifully:

> We can see these signs and symptoms of error in perception—paradox, ambiguity, uncertainty and distortion—as clues to the ways the brain uses sensory information to jump from the patterns of sensory information to the so-different perceptions of objects. When it leaps wrongly, to land in error, we can learn from the pitfalls the strategy it adopts. From our eyes' errors we can look behind the eyes and see something of the most extraordinary and the most complicated functioning system on Earth, to discover at least in outline how it solves problems far too difficult for any computer so far conceived, every time we see an object—or a picture.

This inversion is one to one; every letter inverts to exactly one other letter.

This is a rather extreme modification of a cursive **T**. Fortunately, there is no other letter of the alphabet to confuse it with.

Notice that this shape is perceived as closed when it serves as an **A**, and as open when it serves as an **N**.

STRAVINSKY is correctly capitalized— the descender on the **Y** balances the height of the initial **S**.

Almost anything with a dot on it can serve as an **I**!

In this inversion, no letter inverts to
exactly one other letter.

The initial **R** is rather difficult to fuse.
If it had appeared later in the name,
it would have been disambiguated by
context, but since it is the first letter,
there is no initial expectation.

These three shapes can be grouped
equally well as **B/R**, **I/Q**, or even
L/O/R. Context determines which
grouping stands out.

The line that serves only to join the
E to the **M** becomes the arch of the
N when inverted. In general, cursive
M and **N** are easy to use, since
the top arches that characterize the
two letters vanish into subsidiary
roles as connecting strokes when
the letters are inverted. Almost any
modification can be made to the
bottoms of their strokes without
affecting their legibility!

Notice how this stroke is always on
the left side of a letter, no matter
which way the page is turned.

A five-letter word inverts to a nine-letter word . . . where do all the extra letters come from? The answer is that since the eye tends to scan the tops of letters, it perceives a single letter when the tops are connected, and two when they are disconnected.

Barely an **E**. This is the only letter in **MERRY** that inverts to exactly one letter. All others invert to two. The top crossbar of the **E** is a serif only in the **R**, while the middle crossbar is unusually extended to make the diagonal stroke of the **R**.

Introducing this **M** causes a severe but not necessarily objectionable wrinkle in the tail of the **R**. The inverted form is not read as a **W**, since its top is lower than all the other letters of **MERRY**.

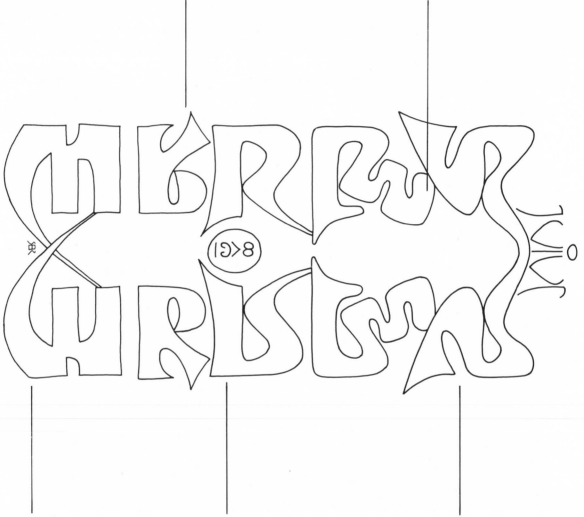

Placing the indentations so that this is read as **CH** and not **W** is a tricky matter.

As in **COMMUNICATION** (page 41), the dot is always grouped with the word below.

A particularly sinuous letter combination: **AS** slides into the tail of the **Y**.

Without this serif, the **I** looks like a lowercase **L**, in which case the following **N** is read as a **U** and the word *luv* jumps out. Since **I** is the first letter of the word, it is extremely important that it be read correctly.

This **S** is one of the most difficult letters. Turning the bottom serif upward improves its legibility, but tends to make the inverse letter, **T**, also read as an **S**.

Notice that the **O** and the **N** are run together—the loop of the **O** doubles as the initial hook of the **N**. Such run-together letters are called *ligatures*. The same **ON** ligature is used also in **COMMUNICATION** (page 41).

Both **INVERSIONS** and **SCOTT KIM** have one dotted **I**, and the two dots have the same shape. This **I** is rather wide, since it must invert to a **V**.

The characteristic upward slant at the top of the **T**s greatly improves their legibility.

Notice that **S** and **K** are properly capitalized. Upper and lower cases are used in the proper places throughout this inversion.

Allegro, an anonymous example of invertible table music.
Originally attributed to Mozart (K. Anhang 284 dd).

Allegro, an anonymous example of invertible table music.
Originally attributed to Mozart (K. Anhang 284 dd).

Music

There is nothing remarkable about it.
All one has to do is to hit the right keys at the right time
and the instrument plays itself.
—J. S. Bach

THE MUSICAL ANALOG of inversion is the *canon*—a composition in which a melody is accompanied by one or more copies of itself. *Canon* means "law" or "rule"— each copy is derived from the original melody by some rule of symmetry. Many transformation rules are possible, including close analogs of most of the symmetries used in inversions.

Canon writing has always been a basic part of a composer's education, unlike palindromes, which are definitely not a central part of a writer's education. Because of their artificial nature, pure canons do not usually stand on their own as compositions, but there are notable exceptions—especially vocal canons. Bach, Mozart, and many other composers have written excellent canons. The last movement of the sonata for violin and piano by César Franck is an example where beauty outshines formality. As a canon it is quite simple, but the very simplicity of its canonic structure is integral to its beauty.

The most familiar type of canon is the *round*, such as "Row, Row, Row Your Boat". The rule here is that each new voice waits two bars before entering. Otherwise, all voices are identical. After the fourth voice enters, the first voice starts its melody again. All four voices then continue chasing each other around in circles for as long as they wish. This image of chasing gave rise to the word *fugue*, which means "flight" or "fleeing".

Canons are much like tessellations, except that the delay is in time instead of in space. The composer works out the harmonic interplay of the voices in the fundamental region and then unwinds the layers of harmony into a linear melody. The challenge is to maintain both coherent melody (recognizable shape) and correct harmony (tight interlocking).

Since canons and tessellations are potentially endless, the problem arises as to how to stop. Visual canons have an advantage here: Paper can be wrapped around to join itself. In fact, rounds are often written on circular staves. Unfortunately, time cannot be so easily manipulated.

New voices, in addition to being delayed, may be transposed, inverted, retrograded, augmented, or diminished. *Transposition* moves the starting note to a different pitch (imagine shifting the piano bench to one side). *Inversion* exchanges low and high pitches, turning ascending intervals into descending intervals, and vice versa (imagine playing a "left-handed" piano). *Augmentation* and *diminution*, respectively, expand and contract the tempo (imagine resetting a metronome). *Retrogression* turns the melody backward in time (imagine a backward-spinning record). Of all these techniques, retrogression is the most difficult to hear, since time is certainly not perceived symmetrically.

In all cases, symmetry may be applied at different levels. In *tonal* inversion or transposition, the composer is allowed to insert accidentals (sharps and flats) freely, allowing an altered melody to stay in the original key. In *exact* inversion, the composer has no such freedom. Exactness is relative. In *perfectly* exact retrogression, the sound waves should leave your ear, funnel through the instrument, be printed on the page by the performer's eye, and clamber back up the pencil of the decomposer.

Retrograde inversion is analogous to 180° rotation— both pitch and time are reflected. The example on the opposite page shows a piece of "table music", which was meant to be laid on a table between duo-violinists, one reading from each end. Note the clever use of the sharp signs, which always apply to the note immediately following to the right.

Inversion appears in music on the melody level as well as on the note level. In the case of invertible counterpoint and chord inversion, the idea is to interchange high and low voices without disturbing up and down within each voice. It is as if the pianist has reversed hands, but not fingers!

```
                              !OHO!
                              !AHA!
                              level
                              rotor
                             racecar
                            Malayalam
                            detartrated
                          Satire: Veritas
                        ...sides reversed, is...
                       Able was I ere I saw Elba.
                      Was it a car or a cat I saw?
                      Madam, in Eden, I'm Adam.
                So patient a doctor to doctor a patient so.
                 You can cage a swallow, can't you, but
                  you can't swallow a cage, can you?
                     This sentence is a palindrome
                        on the sentence level.
                          Ominous cinema
                           We revere you.
```

stripe	Rotation	ripest
stressed	Reflection	desserts
Filer à l'anglaise	Translation	To take French leave
laser	Scaling	Light Amplification by Stimulated Emission of Radiation
grandfather	Repetition	great-great-great-grandfather
rotor	Combination	roto-roto-rotor
CIRCLE ICARUS RAREST	Tessellation	CREATE LUSTER ESTERS
Recursion example contains (using	Recursion	substitution) itself, only nonexpanded.
This sentence	Closure	no verb.
chainlets	Figure/ground	canes hilt
Gödel	Filtering	abcGdefghOijklmDnopqrEstuvwLxyz
Show this bold Prussian	Containment	How his old Russian
that praises slaughter,		hat raises laughter:
slaughter brings rout.		laughter rings out.
Teach this slaughter-lover		Each, his laughter over,
his fall nears.		is all ears.
Escher	Dissection	Cheers
Bach	Symbolism	B♭ A C B♮
now here	Regrouping	no where
Form	Context	Conte−t

Wordplay

The very greatest is the alphabet,
for in it lies the greatest wisdom;
yet only he can fathom it, who truly knows how to put it together.
—Emanuel Geibel in *Gesammelte Werke, Vol. II*, Stuttgart 1893, p. 117.

THE LINGUISTIC ANALOG of inversion is the *palindrome*—a word or sentence in which the order of the letters is the same backward as it is forward. Examples include the words *I*, *deed*, *level*, and the sentence *Madam, I'm Adam*.

Palindromes differ from inversions in that the sequence of letters is reversed, but *not* the individual letterforms themselves. If palindromes are an aspect of wordplay, then we could say that inversions are an aspect of "letterplay". In wordplay, the letter is treated as the smallest unit of information. We do not care how a letter looks—the pattern of pen strokes that make up a letterform has been "sealed off". This situation is reminiscent of musical retrogression, in which the sequence of printed notes is reversed, but not the individual soundforms themselves. (A backward recording of a piano sounds like an organ in which each note ends abruptly.) If all letterforms were reversible, every palindrome would be an inversion as well.

The first set of examples on the facing page illustrates various sorts of palindromes.

Able was I ere I saw Elba. This palindrome consists entirely of reversible words. The middle word, *ere*, is itself a palindrome. Working outward, we find that words occur in reversed pairs: *I/I*, *was/saw*, and *able/Elba*. The boundaries between words occur between the same pairs of letters in the two halves of the sentence. We say that this sentence *preserves* word boundaries. This situation is reminiscent of the inversion **STRAVINSKY**, which preserves letter boundaries.

Was it a bar or a bat I saw? This palindrome is not so simple. With the exception of the word pair *was/saw*, letters are grouped into words differently in the first half of the sentence than in the second. We say that this palindrome *violates* word boundaries. This situation is reminiscent of the inversion **REMBRANDT**, which violates letter boundaries. Notice that the letter "b" occurs twice, once in the first half of the sentence and once in the second—both times at the beginning of a word. (What happens if you replace the "b" with a "c"?) This could not have happened if word boundaries had been preserved.

Madam, I'm Adam. In addition to violating word boundaries, this palindrome plays freely with the placement of punctuation marks in order to clarify the meaning of the wording—the comma and apostrophe each appear in only one half of the sentence. (If this palindrome were in French, accent placement might also be involved.) This situation is reminiscent of tonal inversion in music, which, unlike exact inversion, is able to play freely with the placement of accidentals in order to clarify the meaning of the harmony. Notice that the middle of the sentence can be expanded to accommodate the additional phrase *in Eden*.

So patient a doctor to doctor a patient so. This palindrome is at the word level rather than at the letter level. Word-level palindromes differ from letter-level palindromes in that the sequence of words is reversed, but *not* the sequence of letters within a word. The word is treated as the smallest unit of information. We do not care how a word is spelled—the pattern of letters that make up a word has been "sealed off". If all words were letter-level palindromes, every word-level palindrome would be a letter-level palindrome as well. One can go on to imagine palindromes at the sentence level, the paragraph level, the chapter level, and so on. This attitude leads to the rather strange observation that *every* word is a palindrome—at the word level.

We revere you. A *phonetic* palindrome sounds the same when run backward through a tape recorder, though the spelling may not indicate this. For instance, the spoken word *you* becomes *we* ("ee-oo" becomes "oo-ee"), and *ominous* becomes *cinema*. If English spelling were more orderly, every phonetic palindrome would be a typographic palindrome as well.

The second set of examples on the facing page illustrates wordplay analogs of other types of symmetry. Dissection, for instance, is analogous to the anagram, in which the order of letters is jumbled. Closure is loosely analogous to the fact that a word missing from a sentence can usually be inferred by context. Can you discover how the other analogies work?

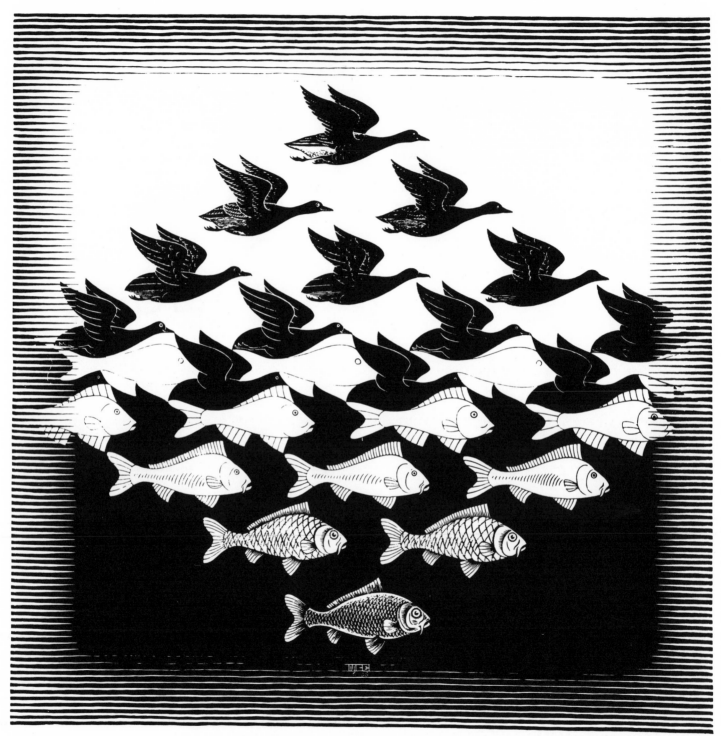

Sky and Water I, by M. C. Escher.

Art

A NAME OFTEN MENTIONED in connection with visual illusions is that of Dutch artist M. C. Escher, whose works treat a wide variety of intriguing visual themes such as figure/ground, two vs. three dimensions, concave/convex, multiple frames of reference, impossible figures, infinity, and mirrors.

Escher's best-known works are his tessellations. *Sky and Water I,* shown opposite, is a study in figure/ground relations. Notice how a single outline delimits both fish and bird. Across the middle, figure and ground become confused. As you scan toward the top or bottom, one or the other animal shape becomes clearly distinguishable. Notice how the neutrally striped border hides the "seam" between the light sky and the dark water.

The real beauty in Escher's work lies not in its mathematical form but in the richness of its metaphorical content. The interlocking of fish and bird shapes is by itself a difficult task. Escher, however, had not the slightest interest in formal exercises, except as they arose naturally in his work. What appeared to mathematicians as a sure sign of deep mathematical study was in fact the inevitable result of a singleminded search for ways to express the fundamental paradox of eternity. The form always emerged in the course of trying to make those expressions as vivid as possible.

Most of Escher's tessellations are based on animal or human forms. On rare occasions, Escher used letterforms. The most notable example appears in his long scroll-like woodcut *Metamorphosis,* which begins with a loosely woven tessellation based on the title, then dissolves into a square grid. At the end of the scroll the square grid reappears, and from it reemerges the title, thus completing the metamorphic cycle.

If you carefully study the excerpt shown to the right, you will see that Escher had to introduce an asymmetry to get the pattern to work. In order to get **M** to meet **E**, Escher expanded the vertical **METAM**s and compressed the horizontal **METAM**s. All other intersections occur at the letter **O**. Clearly, Escher chose to allow mathematical asymmetry rather than create visual imbalance. See page 39 for a tessellation on the English word *metamorphosis.*

The mental processes that one must go through in order to compose an inversion, a canon, a palindrome, or a tessellation are all quite similar. In all cases, the artist juggles formal and aesthetic demands. There is a strong sense of closure when you find a resolution—so strong, in fact, that you wonder whether you have invented something truly new, or merely discovered an already existing pattern. I wish to close the text portion of this book with a quotation from Escher, which vividly describes his design process (see *Fantasy and Symmetry* by MacGillavry).

> The dynamic action of making a symmetric tessellation is done more or less unconsciously. While drawing I sometimes feel as if I were a spiritualist medium, controlled by the creatures which I am conjuring up. It is as if they themselves decide on the shape in which they choose to appear. They take little account of my critical opinion during their birth and I cannot exert much influence on the measure of their development. They usually are very difficult and obstinate creatures.
>
> The border line between two adjacent shapes having a double function, the act of tracing such a line is a complicated business. On either side of it, simultaneously, a recognizability takes shape. But the human eye and mind cannot be busy with two things at the same moment and so there must be a quick and continuous jumping from one side to the other. But this difficulty is perhaps the very moving-spring of my perseverance.

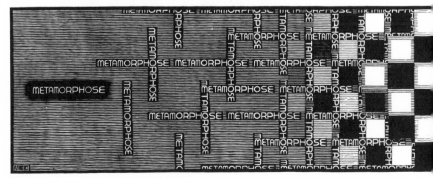

Metamorphose (excerpt), by M. C. Escher.

List of Images (by page)

Short Words

20. **DREAM** (Self-containment). A dream within a dream. Or is it an expanding dream? Notice that **D** is the top half of **R**, and **R** is the top half of **E**—three letters in one symbol. **E** is rather distorted, but reads well enough in context. **A** suggests railroad tracks receding toward some distant vanishing point.

21. **TRUE/FALSE** (Containment). Is there truth in every falsity, or is it that every falsity is based on a truth? **TRUE** is in lower case and **FALSE** is in upper case.

22. **MAN** (Rotation), **WOMAN** (Reflection: left/right). Deceptively simple constructions involving the letter "M". Adding a single crossbar to a symmetric zigzag is enough to distinguish three asymmetrically placed letters: "M", "A", and "N". A lowercase "a" is used in **WOMAN**. Notice that the two words, although closely related, have different symmetries: If you look at this design in a mirror, **WOMAN** will look the same but **MAN** will not. If you turn this design 180°, **MAN** will look the same but **WOMAN** will not.

23. **MUSIC** (Reflection: top/bottom). The letter **M** turns into the three letters **SIC**. The five-lined pen suggests a musical staff. I chose *not* to dot the **I** this time.

24. **EGG** (Dissection). An egg hatches to reveal—an egg. One of the **G**s seems to have flipped over in the process. The same idea is explored in other languages: **AEG** (Danish), **OEUF** (French), **EI** (German).

25. **EDGE** (Self-containment, rotation). Rather difficult to read, especially since the **E** is missing its left downstroke. The intended reading is as four capital letters in a row, all of the same height. The bottommost crossbar of the **E** becomes the crossbar in the next larger **G**, which is part of another **EDGE** twice as large and slightly rotated. Only one instance of **EDGE** is aligned exactly upright. A curious but common reaction to this inversion is "It says *edge* . . . but where are the letters?" Somehow the jumble of letter shapes registers as a gestalt in a totally nonlinear way.

26. **TREE** (Recursion). A tree made of trees. Where do the branches end and the leaves begin? As in all recursive structures, the parts here are the same as the whole. **E** (with a long crossbar) turned sideways becomes **T**—the seed of a new tree. But **T** is bilaterally symmetrical, so we can choose to branch either to the left or to the right. The one letter not involved in the branching, **R**, firmly roots the orientation of each subtree, since **R** is totally asymmetrical.

27. **SUN, MOON** (Rotation: off-center). A simple variation on a basic duality. **SUNS** is naturally symmetrical; **MOON** requires a bit of letter regrouping.

Words Describing Symmetries

28. **SYMMETRY** (Rotation), **ASYMMETRY** (No symmetry). Self-descriptive words. **SYMMETRY** is symmetrical, and **ASYMMETRY** is asymmetrical. The **S/Y** combination in **SYMMETRY** also appears in **STRAVINSKY**. Other examples of self-descriptive words are *short*, *recherché*, *polysyllabic*, *hissing*, and *italicized*. Is *self-descriptive* self-descriptive?

29. **UPSIDE DOWN** (Rotation). Describes its own symmetry. This inversion can be considered an answer to a fascinating problem: Design a picture that always looks upside down, no matter which way you turn it.

30. **MIRROR** (Reflection: left/right). Describes its own symmetry. Notice how the dot at the vanishing point has been placed ambiguously on the **I**.

31. **LEVEL** (Self-containment). Levels within levels. This inversion is similar to **DREAM**, except that the vanishing point is at the bottom instead of the top. Notice that *level* is a palindrome.

32–35. **INFINITY** (Rotation: off-center). Four ways to present one idea. (1) Running **INFINITY** in a straight line has the problem that the word gets arbitrarily chopped off at the edge of the page. There is also a problem with extra dots—the dot on an upside-down **I** serves no function in a right-side-up **INFINITY**. (2) Closing the line into a circle avoids loose ends. (3) Stacking the straight lines solves the problem of extra dots—the dots hanging below one layer now become part of the next layer. (4) Finally we can combine both circle and stack by wrapping the line into a spiral.

36. **FIGURE** (Tessellation: figure/ground). A picture that is all **FIGURE** (foreground) and no **GROUND** (background). There are many ways to present this idea; the presentation here pays homage to M. C. Escher's woodcut *Sky and Water I* (page 112). Black and white are equally prominent in the middle. As the eye travels upward, the white figures shrink on what is clearly seen as a black ground. As the eye travels downward, the black figures shrink on what is clearly seen as a white ground.

Long Words

37. **PROBLEM** (Reflection: upper left/lower right), **SOLUTION** (No symmetry). Reflecting on this **PROBLEM** yields a surprising **SOLUTION**. Notice that reflection about a diagonal axis preserves a pen angle of 45 degrees, so that calligraphic conventions are maintained. In contrast, the pen angle of the right half of **MIRROR** is contrary to the angle used in normal calligraphy.

38. **LARGE/SMALL** (Rotation). "Soon her eye fell on a little glass box that was lying under the table: she opened it and found in it a very small cake, on which the words 'EAT ME' were beautifully marked in currants. 'Well, I'll eat it,' said Alice 'and if it makes me grow larger, I can reach the key; and if it makes me grow smaller, I can creep under the door: so either way I'll get into the garden, and I don't care which happens!' " —from *Alice in Wonderland*.

39. **METAMORPHOSIS** (Tessellation: rotation). A variation on Escher's **METAMORPHOSE** (p. 113). Again M meets E and O meets O, but this time in a different manner. The English spelling of *metamorphosis* allows us an additional overlap: **SIS**. Notice that **METAMORPHOSIS** appears in four orientations radiating from the **M/E** vortices. This tessellation has a higher order of symmetry than Escher's, which contains **METAMORPHOSE** in only two orientations.

40. **SYNERGY** (Tessellation: rotation). Synergy is the phenomenon in which the energy of a group working together is greater than the sum of the energy of its individuals. In this pattern there are two centers of rotation around which words spin like pinwheels: The first **S** turns into **Y**, and **E** turns into **R**.

41. **COMMUNICATION** (Rotation). A different solution to the extra-dot problem. Five letters turn into eight. I could have written **COMMUNICATION** in a single unhyphenated line rather than in two . . . why didn't I?

42. **HORIZON** (Rotation). The horizon splits **HORIZON** into two identical parts, though not in the manner of a reflective body of water.

43. **SEQUOIA** (Reflection: left/right). *Sequoia* also has the interesting property that each of the five vowels is included exactly once. Note the ignored lines in the **O** and **I**. The tail of the **Q** invades the **O**. The **S** is open, while the lowercase **A** is closed.

44. **DYSLEXIA** (Reflection: left/right). Dyslexia is a physical condition in which a person tends to confuse left and right. This condition is especially apparent in children who are learning to read, which is why imitations of children's writing deliberately include reversed letters.

Variations on *Gödel, Escher, Bach*

(Inspired by *Gödel, Escher, Bach: an Eternal Golden Braid* by Douglas R. Hofstadter.)

45. **KURT GÖDEL** (Reflection: left/right). The ambiguous, centrally placed umlaut is similar to the dot on the **I** in **MIRROR**. The first letter of each name becomes two letters upon reflection.

45. **MAURITS ESCHER** (Reflection: left/right). The **A/R** transformation would work the opposite way in Cyrillic, since that language includes a letterform that looks like a backward **R**, but does not include a forward **R**.

45. **J. S. BACH** (Reflection: left/right). Completes the trio. The **B/A** combination is quite natural, but the strong bilateral symmetry might lead you to expect "b" to turn into "d".

46. **J. S. BACH** (Reflection: lower left/upper right).⌡The **B** really is symmetrical. It looks topheavy because it has not been visually corrected—the upper bowl in the letter "B" is normally slightly smaller than the lower bowl.

47. **BACH** (Symbolism). In German notational practice, "B" is what we call "B flat", and "H" is what we call "B natural" (all other pitches have their usual names). This means that the name *Bach* can be played as the four-note melody "B flat, A, C, B natural"—a fact that Bach himself was well aware of, and in fact incorporated discreetly into several of his compositions. Many composers have written variations on "B-A-C-H". In this inversion, the letters **B** and **H** are replaced with the appropriate accidentals.

47. **J. S. BACH** (Regrouping). The initial **B** can also be read as **JS**. This ambiguity is closely related to the German "ss" ligature—in German printing, double "s" is replaced with the symbol "ß", which is a stylized joining of a tall thin "s" to a more ordinary "s". To readers not familiar with German this ligature looks more like an uppercase "B", or perhaps a lowercase beta.

48, 49. **M. C. ESCHER** (Tessellation: rotation). Two tributes to the master of tessellations. The **M/E** combination is the same as the one used by Escher himself in the print *Metamorphosis*. Like **SYNERGY**, this tessellation has two centers of rotational symmetry, one clockwise, the other counterclockwise. Reversing the directions of the whorls produces the second tessellation, in which Escher's name reads vertically down instead of horizontally across.

50. **M. C. ESCHER** (Rotation). The **M** becomes two and a half letters when inverted, just as in **MARTIN GARDNER**.

Variations on Calligraphic Themes

51. **MERRY CHRISTMAS** (Reflection: top/bottom). A more difficult problem—five letters turn into nine. The key here is that since the eye draws most of its information from the tops of letters, two shapes connected at the top will tend to be read as two letters, while two shapes connected at the bottom will tend to be read as one letter. The exact mirror symmetry is maintained in the date, the crowning **KIM**, and the signature **SEK**. There is one detail that is *not* symmetrical—do you see it? See page 106 for further description.

52. **MERRY CHRISTMAS** (Reflection: left/right). Evokes many images: mountains, a crown, a cross, a sled. The solution to **MERRY** calls to mind the solution to **MIRROR**.

53. **MERRY CHRISTMAS** (Rotation). A fairly typical inversion, all lowercase. No letter maps into exactly one other letter. Figures 51-53 were originally used as our annual family Christmas card. This design also includes the first names of the members of our family: Lester and Pearl are my parents, and Grant and Gail are my brother and sister.

54. **HANUKKAH** (Rotation). The same ambiguously crossed **A** that is used in **MAN**. The tops of the **K**s suggest candle flames, while the overall style suggests Hebrew.

55. **FRIENDS OF CALLIGRAPHY** (Regrouping). The name of an informal organization in the San Francisco area that promotes calligraphy. The only letter shared by **FRIENDS OF** and **CALLIGRAPHY** is **I**—everything else serves a double purpose.

56. **ALPHABET** (Regrouping). Each line is used twice—no more and no less—as part of two different letters. Coloring the outline one way reveals half the alphabet; coloring it the other way reveals the other half. I've allowed letters to appear in arbitrary order and in arbitrary rotations, but not to be flipped over.

57. **ALPHABET** (Reflection: left/right). Working with the alphabet has the nice property that, unlike working with words, line breaks can be inserted at any point.

58. **ALPHABET** (Reflection: top/bottom). Up/down reflection turns out to be much more awkward to manage than left/right. Particularly difficult letters included **G**, **Q**, and **W**.

Contemporary Names

59. **MARTIN GARDNER** (Rotation). An author who plays with the beauty and humanity of mathematics. (See *The Ambidextrous Universe*, by Gardner.) The central **G** combines aspects of both lower- and uppercase **G**s.

60. **PILOBOLUS** (Dissection). A modern dance group that plays with improbable amalgamations of bodies into fanciful creatures. (See *Pilobolus*, by Matson.) Notice the pointed "spurs" on the **P**, **B**, and **S**, which complement the rounded corners of the **O**.

61. **BERROCAL** (Dissection). A sculptor who plays with human and animal forms as baroquely interlocking puzzle forms. (See "The interlocking puzzle sculptures of Miguel Berrocal", by Gardner.) All letters are in the correct orientation, except for one of the **R**s.

62. **ASIMOV** (Rotation). An author who plays with the interconnections between all areas of human imagination. (See *The Left Hand of the Electron*, by Asimov.) The **A/V** combination, also used in **VICTORIA,** is easy; the real challenge is **S/O**.

63. **JORGE LUIS BORGES** (Containment). An author who plays within the intricate labyrinths of symbols and the symbolized. (See *Labyrinths*, by Borges.) It is fortunate that first and last names share so many letters.

64. **MITSUMASA ANNO** (Rotation). An artist who plays with visual surprise and nonverbal narrative. (See *Anno's Alphabet*, by Anno.) In Latin, *anno* means "year", whence comes "A.D."—"anno Domini", or "in the year of the Lord". Anno signs many of his works with "anno" followed by the year.

65. **J. RANDI** (Rotation). A magician who plays with attention, misdirection, and the willingness to be deceived. (See *Flim Flam*, by Randi.) All six letters are rotations of the same basic shape—only the way the strokes have been thickened changes. Unfortunately, Mr. Randi goes by "Randi" or "The Amazing Randi", not "J. Randi". **R** is directly traced from the "R" in Randi's signature.

66. **RICHARD L. GREGORY** (Rotation). A scientist who plays with visual perception and cognition. (See *The Intelligent Eye*, by Gregory.) The only substantially distorted letter is **D**.

Historic Names

67. **GUTENBERG** (Rotation). The inventor (in Western culture) of movable metal type. The style is based on the type style used in Gutenberg's bible. In order not to offend the scribes too much, Gutenberg modeled his type style very closely on the calligraphic style of the time (black letter). The transformation between the first and last **G**s is similar to that used in **GREG**.

68. **REMBRANDT** (Rotation). 17th-century artist. This inversion is nowhere one to one. No letter turns over to become exactly one other letter. For instance, **R** turns over to become two letters: **DT**. See page 105 for further description.

69. **MOZART** (Rotation). 17th-century composer. Although Mozart did not write the invertible violin duet, reprinted on page 108, it is often attributed to him, and such a construction would have been well within the range of his inventive spirit.

70. **STRAVINSKY** (Rotation). 20th-century composer. This inversion is entirely one to one: Each letter turns over to become exactly one other letter. For instance, **S** turns over to become **Y**. See page 104 for further description.

71. **WAGNER** (Rotation). 19th-century composer. A small redesign can turn this name into **WIGNER**.

71. **WIGNER** (Rotation). A physicist who plays with symmetry principles underlying particle interactions. (See *Symmetries and Reflections*, by Wigner.) A small redesign can turn this name into **WAGNER**.

72, 73. **EINSTEIN** (Tessellations: glide reflection and rotation). 20th-century physicist. Eight letters are condensed into two symbols in a remarkably dense tessellation pattern, here shown in two forms. (1) Both right- and left-handed (mirror-image) forms of the name are present in this tessellation. (2) The same name can be woven together in a different, less dense, planar pattern that can be bent around a sphere, suggesting gravitationally warped space, an idea pioneered by Einstein.

First Names

74. **ANNIE, CHRIS, DANIEL, DAVE, GORDON, GREG** (Rotation). The history of **ANNIE** is described on page 100. **CHRIS** is the middle of **MERRY CHRISTMAS**.

75. **IRENE, JILL, KIM, LEON, MICHAEL, NAOMI** (Rotation). In this case, **LEON** inverted is *not* **NOEL**!

76. **NINA, OTTO, PHILIP, ROY, RUDY, SCOTT** (Rotation). **OTTO** naturally has both rotational and reflective symmetry. Turning this name inside out reveals another word with the same symmetry: *toot*. For a long time the one name that I couldn't invert was my own. Then I discovered a solution to **SCOTT**, which I am quite pleased teeters right on the edge of legibility, suggesting many different images. People often reverse my name inadvertently—"Kim Scott" is a much more likely name in America than "Scott Kim".

77. **VICTORIA** (Rotation). The main problem here is how to rationalize the tail of the **R**.

In Other Words

Cover, also page 4, frontispiece. **INVERSIONS/SCOTT KIM** (Rotation). Since this design appears on the cover, I worked especially hard on making it legible. The most critical section turned out to be the first few letters of **INVERSIONS**: If the eye starts off on the wrong foot (so to speak), it has a hard time recovering. In earlier versions, **INV** tended to be read as **LUV**. The final design still has its ambiguities, but I decided that it was more important that the cover reflect what was inside. See page 107 for further description.

6. **LESTER/PEARL** (Figure/ground, rotation). A very special couple. I first presented this design to my parents by rendering it in chocolate and vanilla frostings on a cake.

8. **DOUGLAS HOFSTADTER/AI** (Containment, rotation). After doing Jef's name backward, I felt compelled to work on the name of my foreword-writer. After rejecting several rather agonizingly illegible variations, I found this much simpler solution. AI stands for Artificial Intelligence, which is Douglas Hofstadter's area of research. The letterforms are modified from the typeface *Helvetica*.

16. **FIGURE** (Figure/ground, rotation). The first inversion I designed. See the text on page 16 for further description.

17. **FIGURE** (Figure/ground, tessellation). The second inversion I designed. The full presentation of the intended tessellation pattern is shown on page 36. A slightly different version is reproduced in *Gödel, Escher, Bach*. See the text on page 17 for further description.

120. **JEF RASKIN** (Reflection: left/right). Jef legally adopted this spelling so that he could write his first name symmetrically. Here is a way his last name can join in the game.

Bibliography

Anno, Mitsumasa. *Anno's Alphabet: An Adventure in Imagination.* New York: Crowell, 1975.

Asimov, Isaac. *The Left Hand of the Electron.* New York: Dell, 1972.

Bakel'man, I. Ya. (Susan Williams and Joan W. Teller, trans.). *Inversions.* Chicago: University of Chicago Press, 1974.

Barsley, Michael. *Left-handed People: An Investigation into the History of Left-handedness.* North Hollywood, Calif.: Wilshire Book, 1977.

Bergerson, Howard. *Palindromes and Anagrams.* New York: Dover, 1973.

Borges, Jorge Luis. *Labyrinths: Selected Stories and Other Writings.* New York: New Directions, 1964.

Carroll, Lewis (Martin Gardner, ed.). *The Annotated Alice: Alice's Adventures in Wonderland and Through the Looking Glass.* New York: New American Library, 1960.

Craig, James (Susan Craig, ed.). *Designing with Type.* New York: Watson-Guptill, 1971.

David, Hans T. *J. S. Bach's Musical Offering.* New York: Dover, 1972.

Edwards, Betty. *Drawing on the Right Side of the Brain.* New York: St. Martin's Press, 1979.

Ernst, Bruno. *The Magic Mirror of M. C. Escher.* New York: Random House, 1976.

Gardner, Martin. *The Ambidextrous Universe: Mirror Asymmetry and Time-reversed Worlds.* New York: Scribners, 1979.

Gardner, Martin. "The puzzle sculptures of Miguel Berrocal." *Scientific American,* January 1978, Vol. 238, No. 1, pp. 14–26.

Gregory, R. L. *The Intelligent Eye.* New York: McGraw-Hill, 1970.

Gregory, R. L., and Gombrich, E. H. *Illusion in Nature and Art.* New York: Scribners, 1973.

Held, Richard (ed.). *Image, Object, and Illusion (Readings from Scientific American).* San Francisco: Freeman, 1974.

Hofstadter, Douglas R. *Gödel, Escher, Bach: an Eternal Golden Braid.* New York: Basic Books, 1979.

Jensen, Hans. *Sign, Symbol and Script.* New York: Putnam's, 1969.

MacGillavry, Caroline H. *Fantasy and Symmetry.* New York: Abrams, 1976.

Mandelbrot, Benoît. *Fractals: Form, Chance, and Dimension.* San Francisco: Freeman, 1977.

Mann, Alfred. *The Study of Fugue.* New York: Norton, 1965.

Massin. *Letter and Image.* New York: Van Nostrand Reinhold, 1970.

Matson, Tim. *Pilobolus.* New York: Random House, 1978.

McKim, Robert. *Experiences in Visual Thinking.* Monterey, Calif.: Brooks/Cole, 1980.

Nelson, George. *How to See: A Guide to Reading Our Manmade Environment.* Boston: Little, Brown, 1977.

Randi, The Amazing. *Flim Flam. A Guide to Unicorns, Parapsychology, and Other Delusions.* New York: Lippincott and Crowell, 1980.

Senechal, Marjorie, and Fleck, George (eds.). *Patterns of Symmetry.* Amherst: University of Massachusetts Press, 1977.

Shepard, Roger N., and Cooper, Lynn A. "Mental transformations in the identification of left and right hands." *Journal of Experimental Psychology,* 1975, Vol. 104, No. 1, pp. 48–56.

Shubnikov, A. V., and Kopstik, V. A. *Symmetry in Science and Art.* New York: Plenum Press, 1974.

Weyl, Hermann. *Symmetry.* Princeton, N.J.: Princeton University Press, 1952.

Whistler, Rex, and Whistler, Lawrence. *AHA.* Boston: Houghton Mifflin, 1978.

Wigner, Eugene P. *Symmetries and Reflections: Scientific Essays of Eugene P. Wigner.* Bloomington: Indiana University Press, 1967.

Zapf, Hermann. *About Alphabets.* Cambridge, Mass.: M.I.T. Press, 1970.

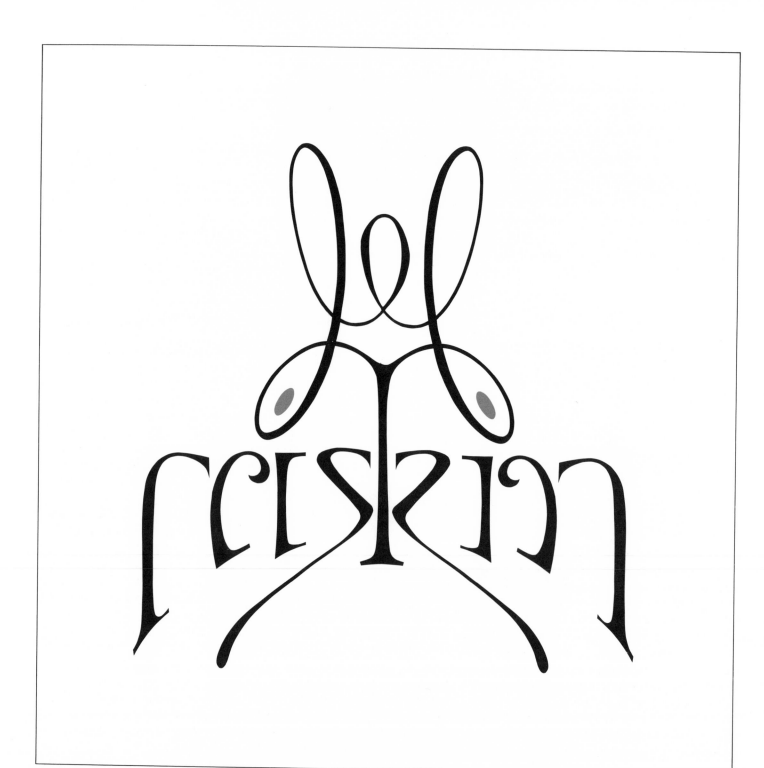

Backword by Jef Raskin

1. What's in a Name?

Some years ago, long before meeting the author of this book, I shortened my first name to its present form. There were a number of reasons for doing so: It was distinctive, the second "f" in the normal spelling was phonetically redundant, and (what was most important to me) my name now could be written in a number of symmetrical ways.

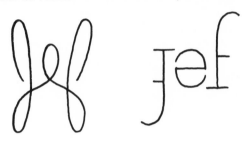

Scott Kim probably would not have had to change a name to make it symmetrical, as he proved to me by drawing my last name symmetrically. This possibility had never occurred to me. My pen name (under which I write music) is "Erasmus Smums". "Smums" of course is a palindrome. "Erasmus" is distinguished and sounds good with "Smums".

Where does all this silliness come from? Why should I care if my name is written one way or another, why does Doug Hofstadter prate on joyously about sentences that refer to themselves, and why has Scott spent some of his time for half a decade drawing words whose representation is graphically arresting, self-referential, or both?

One day Scott, Doug Wyatt, and I sat down at a piano and improvised a six-part fugue. Why would anybody (much less three of us) be consumed with delight at pressing buttons on this machine that make hammers strike strings that vibrate and in turn cause our own eardrums to vibrate? Besides, soon after we stopped pressing the keys the sound stopped, having done no speck of useful work, having carried no cogent message, and having no monetary value whatsoever.

For that matter, why are you reading this book? Can't you find anything better to do with your time? Something useful? Well, no matter now, you've finished the book and uselessly marveled at Scott's imagination and skill. You're free to go, and I hope you wonder at the strange creatures we are, so much a mixture of the good, the bad, and the wonderfully irrelevant.

Strange how much human accomplishment and progress comes from contemplation of the irrelevant.

2. Dandy Doodles

You do a doodle and it's normal. You get caught up in the doodling and you're a bit strange. You do it for a few years and thoroughly explore it and you're an artist. For some people, the hard part is getting through the period between idle amusement and artistic accomplishment. In that period you have nothing to show, or what you have to show is not recognized as being important. What you're doing might be considered cute, even interesting, but a mere hobby, a waste of time, nothing serious—shouldn't you be doing something worthwhile?

Except for a few friends who give you encouragement and support. Either that or you give up or turn inward, embittered, and push on.

Having worked with students in the arts, sciences and humanities, I am convinced that most (if not all) people can be creative and have a good time at it. I am not convinced that anybody can have a really good time without being creative. What has haunted me for years is the knowledge that most people go through life thinking that ingenuity like Scott Kim's is beyond them when, in fact, if given a spark of encouragement, they can do things quite as interesting. I have seen it happen with whole classes of students when a good teacher fires their self-confidence.

Some people learn of their power in only one area and, having learned to be confident and free there, become convinced that their talent lies only in that sphere. Others,

like Scott Kim, feel free to roam through any region of learning or doing, limited only by time. He has realized the principle in general rather than as applied to one discipline.

I remember being frightened of trying to learn to drive. I told myself that if so-and-so could do it, then I could too. The same reasoning helped me through a number of fields. It is true for you, too. "If Scott can do it, so can I", you might think. And you'd be right. Remember to do things not for any rewards they might bring, but for the joy of doing them—and when you're convinced your stuff is good, and you want to bring it to the world, then either it'll happen on its own or (as Scott has done with this book) you'll have to put in a lot of work to make it visible.

3. Talking Sides

The drawings in this book represent a general concern with symmetry, intrigue, delight, and elegance that is found in all good scientific and artistic work. Scott's use of his aesthetic extends beyond the drawings. I wish the readers could hear him playing Bach fugues on the piano. Even his face and body are symmetrical. In short, he is devoted in every way to things that have Symmetry, Intrigue, Delight, and Elegance, or, to make an acronym, to things that have SIDE.

The careful reader will notice my lapse and ask, "But which side?" The only reply is that, after Scott gets through with it, both sides are the same. Or, perhaps you point out that something may have only one side, and unlike most issues, there is no other side to be had.

In that case, you have forgotten the inside. Most cases have an inside; in fact, a case would not be much use without an inside. But, you may comment, where is the inside of an upper case or a lower case? How about the very famous cases of Mr. Sherlock Holmes? He often closed his cases, but it is not recorded what was on the inside. Probably his cases were made of leather, and of a quality that is no longer produced in these mechanized times.

But time is no longer mechanized, but electronicated. And time, as the song tells us, is on our side. This brings up the question: Does time have sides? Time does have Intrigue, Delight and Elegance, but does it have Symmetry? And if it does, then what is on the other side of time? The answer: emit. But what does it emit? An item, a mite? What does a random generator emit? Those I've played with emit only numbers. But is that random? Why doesn't it emit elephants? Does a random sequence have side? Intrigue, Elegance, Delight to be sure, but is there Symmetry? Some other kind of tree? Can only god make a tree? Does god play dice with the universe? Is the only anagram for side dies? Does god play dies with the universe?

Does god play? And if it plays, which side wins?

This book (dear reader) was written, designed, illustrated, and typeset
 by the author

with abundant support from
Ed Kelly, Chris Morgan publishing
Ellen Klempner, Richard Kharibian design
Virginia Mickelson production
Douglas Hofstadter, Dianne Kanerva copy editing
Peg Clement proofreading
Donald Knuth, David Fuchs typesetting
John Warnock images
Suzanne West cover

typeface Optima
paper Warren's Olde Style